MACABRAS

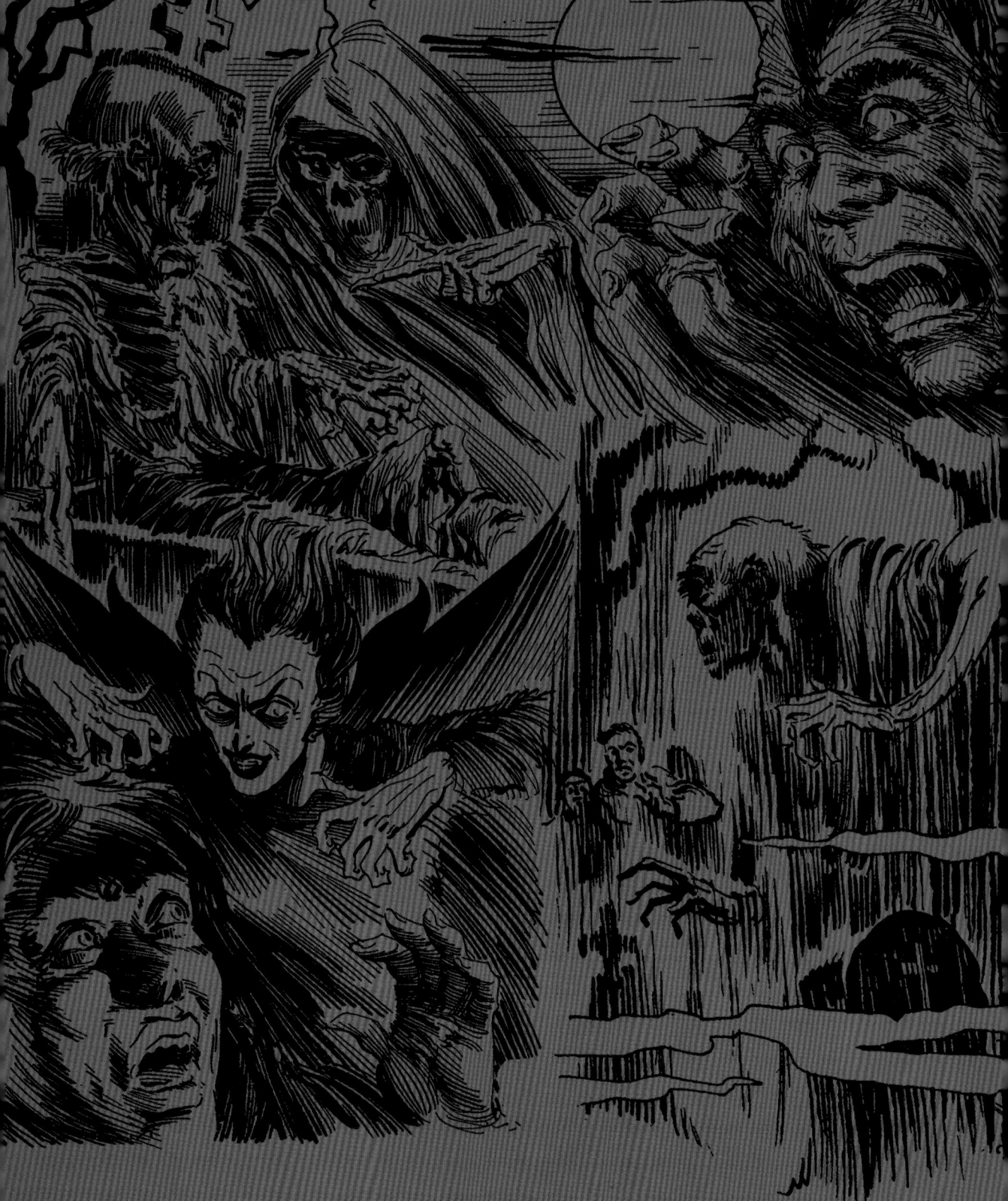

All rights reserved. No part of this publication may be reproduced, distributed, or transmitted in any form or by any means, including photocopying, recording, or other electronic or mechanical methods, without written permission of the publisher or author, exceptions being cases of brief quotations embodied in critical articles or reviews and pages where permission is specifically granted by the publisher or author. To the best of our knowledge, the information in this book is correct and complete. Every effort has been made to ensure that credits comply with the information supplied.

A CIP catalogue record for this book is available from the British Library. Printed in China

First published in 2023
by Korero Press Ltd
ISBN-13: 9781912740215
www.koreropress.com
© Korero Press Ltd

English translation by Joe Williams
www.joewilliamstranslation.com

MACABRAS

The Horror Comic Art of Jayme Cortez
Volume 2

— by —

Fabio Moraes

with an introduction by Paul Gravett

Dedicated to
the memory of José Ruy

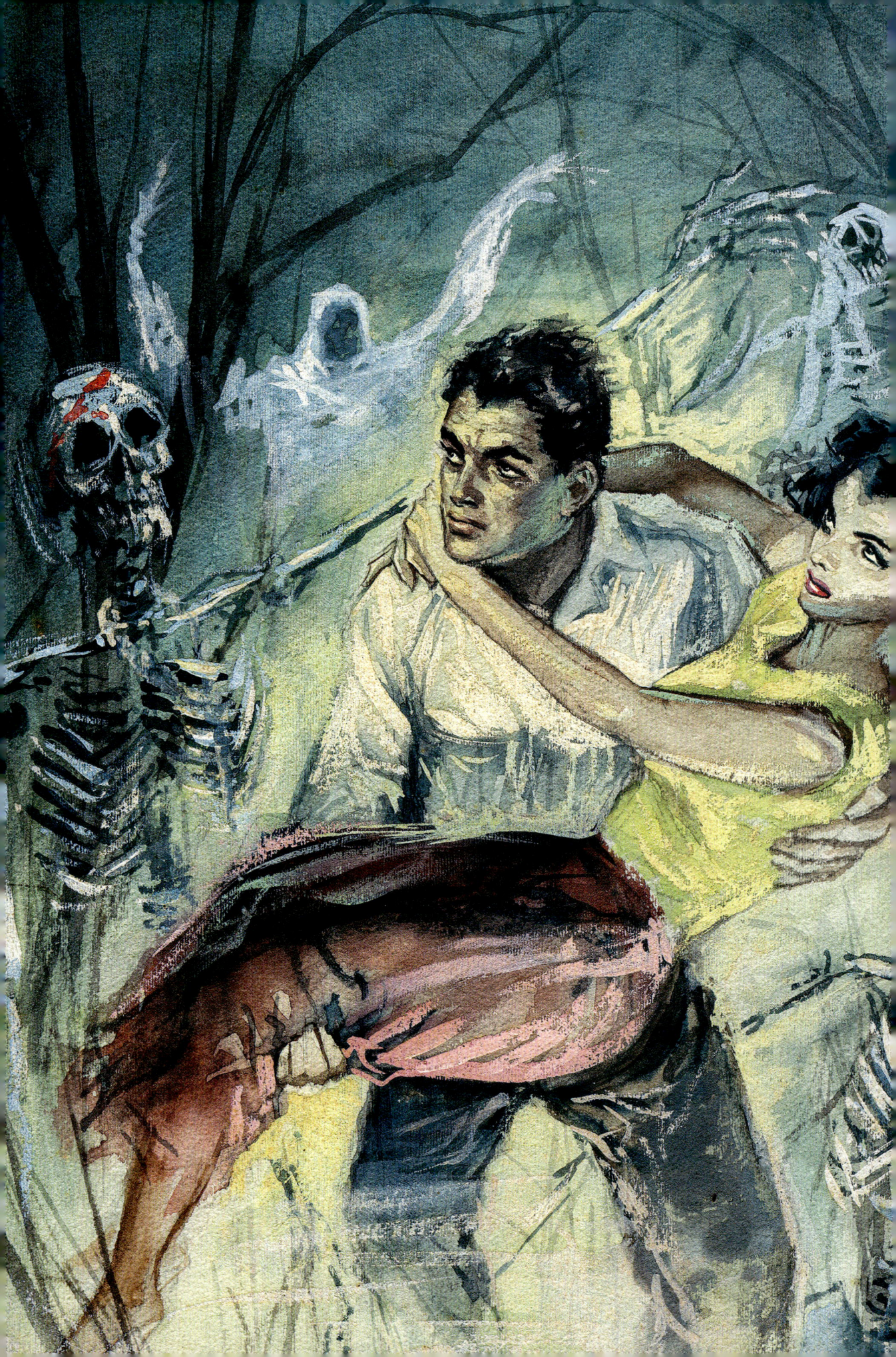

CONTENTS

PREFACE .. 7

FOREWORD BY PAUL GRAVETT 9

A VIRTUOSO OF ILLUSTRATION 13

THE PORTRAIT OF EVIL 1961 27

THE PORTRAIT OF EVIL 1973 31

SELEÇÕES DE TERROR ... 40

HISTÓRIAS MACABRAS .. 61

CLÁSSICOS DE TERROR ... 79

HISTÓRIAS SINISTRAS ... 91

HISTÓRIAS DO ALEM ... 97

SUPER BÔLSO .. 101

TERROR MAGAZINE .. 103

JOTAESSE .. 105

EDGAR ALLAN POE ... 108

CREATING A POSTER ... 110

BLACK AND WHITE ILLUSTRATIONS 116

ACKNOWLEDGEMENTS .. 126

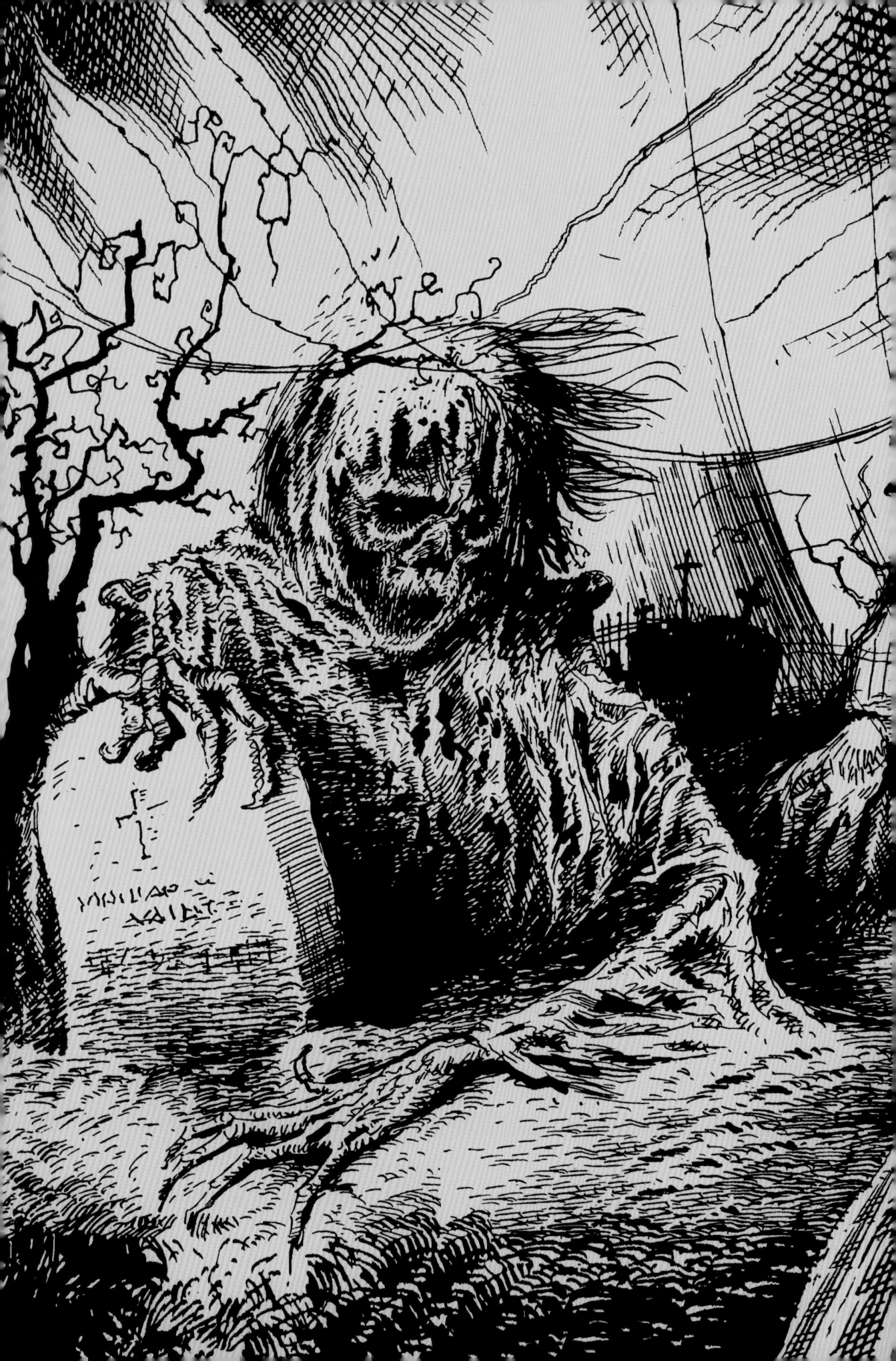

PREFACE

PORTUGUESE-BORN Jayme Cortez is considered one of the greatest illustrators of Brazilian comics, reaching the height of his formidable powers during the 1950s and 1960s, when he painted covers for a variety of horror publications. His reputation as a living master of his craft endured for several generations, and his influence is still very much in evidence today. Endowed with a prodigious artistic talent and a vast arsenal of painting techniques, Cortez seamlessly traversed a wide range of mediums, and when he passed away in 1987 at the age of 60, he left an enormous collection of work. Today, Cortez is highly regarded by illustrators, comic book artists, and professionals working in the comics industry aeound the world. Astonishingly, however, much of his work remains unknown to the wider public internationally. Thankfully, this is beginning to change, in part due to publications such as this one from Korero Press.

This book features every cover that Jayme Cortez created for the Brazilian publishing house Continental/Outubro, as well as various pieces he produced for other publishers, among them black and white illustrations and comic strips, alongside an illuminating biography and a glimpse into his creative process. So, make yourself comfortable and get ready to enjoy the art of Jayme Cortez – you're in for a treat.

FABIO MORAES
São Paulo, Brazil

Opposite: Publicity artwork for Outubro, circa 1960.

Left: Fabio Moraes with Jayme Cortez's sons, Leonardo Cortez and Jaime Cortez Filho, 2000.

PREFACE | 7

FOREWORD

THE COVER OF A HORROR COMIC is designed to grab your attention, make your spine tingle, and set your heart racing, all while promising yet more shivers and shocks inside. It must entice you into picking up the comic and daring to open it, leaving you with no choice but to buy it. And when it comes to devising such seductive visuals, I am convinced that Jayme Cortez must be one of the horror comic universe's most outstanding cover artists. And yet, very surprisingly, relatively few horror fans have heard his name. Born in Portugal, Cortez pursued his career in Brazil, where he became much in demand, creating brilliant cover art for almost every magazine genre going, from comedy to cowboys. And now that his extensive body of illustration in the horror field has finally been brought together, in this book and its companion volume *Terror*, we can begin to grasp the sheer scale of his skills and achievement.

In the comic book industry, the horror genre has attracted some of the very best illustrators, from EC Comics' Johnny Craig, Jack Davis and, especially, the "Ghastly" Graham Ingels on *Tales from the Crypt* and other titles, to Frank Frazetta and Ken Kelly's painted covers and a host of Spanish maestros on Warren's *Creepy*, *Eerie*, and *Vampirella* magazines. Without doubt, Jayme Cortez ranks alongside these masters in terms of quality, but also in quantity because somehow he managed to produce one arresting cover after another, month in month out, and in several styles and media.

My personal introduction to Cortez's brilliance came when I was invited to the first International Comics Biennial in Rio de Janeiro, Brazil, in 1991. Among its superstar guests was the great US cartoonist Will Eisner, and I was lucky enough to be present, up on a rooftop in a setting straight out of Eisner's *The Spirit*, while he reminisced with the multitalented Brazilian cartoonist and researcher Álvaro de Moya. The pair recalled how Cortez had helped produce a landmark exhibition of original comic art in São Paulo in 1951; and of course, Cortez's works were displayed there alongside those by such American masters as Milton Caniff, Alex Raymond, and Al Capp – and they more than lived up to them. So, I thought, how can I learn more about Cortez?

Luckily, at the Biennial I also met one of the most knowledgeable and enthusiastic specialists on the history of comics, particularly Brazilian: Carlos Baptista, known to everyone as "Patati". He became my guide and my friend and gave me a crash course in how Brazil had sidestepped the neutering self-censorship imposed by the Comics Code of 1954, a set of prohibitive rules about editorial content that had driven US horror comics books almost out of existence. The dark genius of American horror comics refused to be buried, however, and it lived on in Brazil, where a locally produced version blossomed and then boomed. At the Biennial, there were just a few older Brazilian comics on sale, and the sight of my very first Cortez cover, for *Histórias Macabras* no. 2, was seared into my mind forever. I was struck by the way his painterly skills conjured up not only the monstrous, utterly convincing physicality of the creature carrying off its victims, but also the fetid, mist-enshrouded setting, disappearing into tangled vines and a sickly yellow sky. Brazilian comics were "para adultos" (for adults only), and they had not been infantilized by restrictive editorial standards.

With Patati's help and wisdom, I sought out further examples of Cortez's work and more information about the man. In 2015, I had the good fortune to talk again with Álvaro de Moya, in São Paulo over dinner, and he shared his memories of his great friend and fellow comics professional.

Opposite: Jayme Cortez painting the cover of *Contos de Fadas* (Fairy Tales) no. 26, published by La Selva in May 1958.

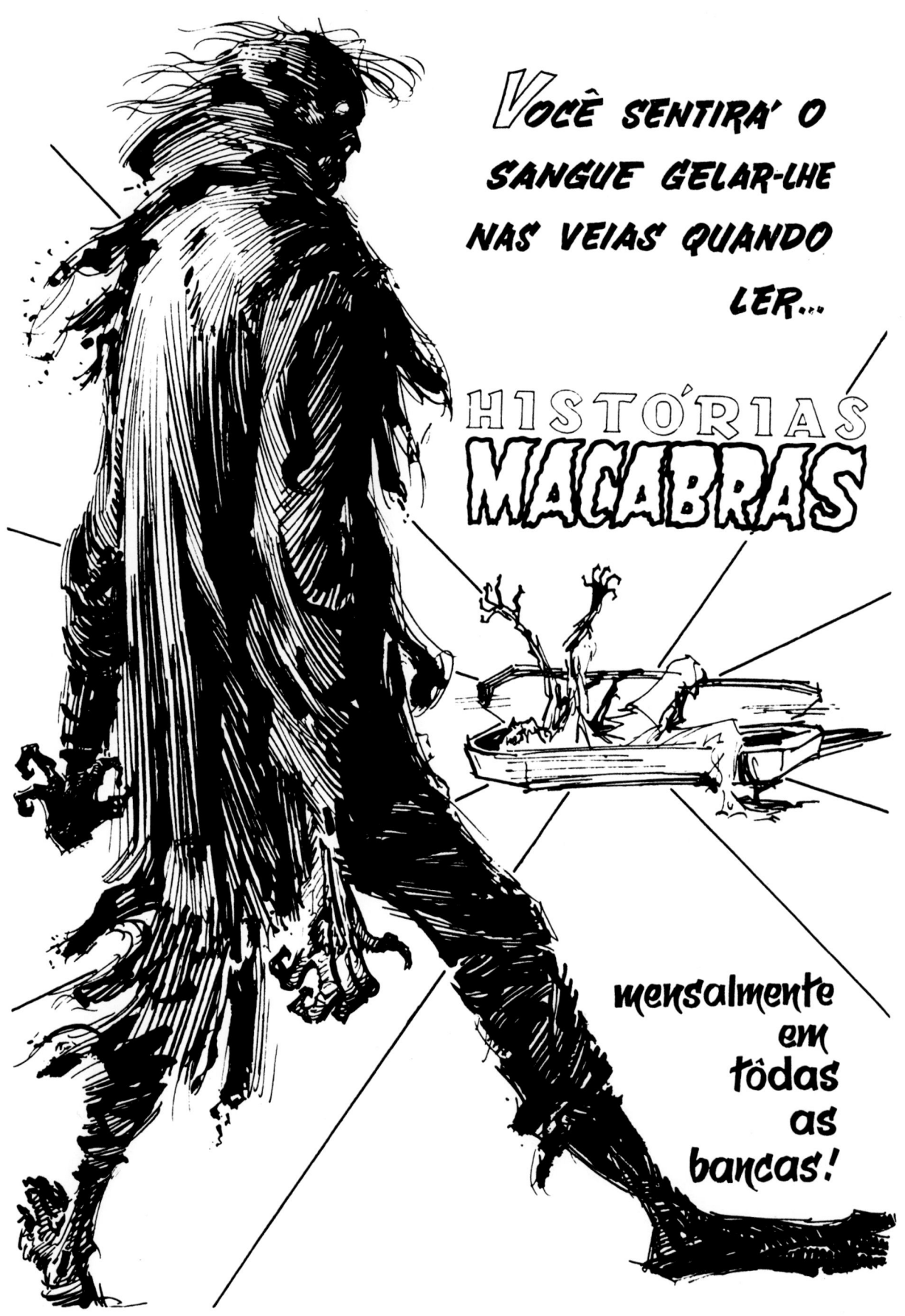

Another generous expert on Cortez's work is Skye Ott at Komic Kazi International, whose family's massive collection of exceptional vintage comic gems, gathered by multiple generations, is worthy of a museum of its own. Skye shared with me images and information which revealed the full range and excellence of Cortez's output; and most importantly, I got the chance to see his rare surviving artworks, which convinced me that a book that would unite them all was both overdue and essential. Sadly, we lost Patati, and apparently his research into the history of Brazilian comics as well, but thankfully we found Cortez's biographer and curator Fabio Moraes, who brings to this endeavour his deep knowledge and insight about the artist's life, art, and creative processes.

In creating his horror comic covers, Cortez strove for impact and believability. He would often shoot reference photos using live models, instructing them to enact scenes and strike the precise poses and gestures he wanted to capture – the incredulous, terrified facial expressions, the tense hands with their seized fingers, the arched and twisted bodies. In this book, if you compare the reference photos with the finished cover artwork, you will notice that Cortez's staged shots were usually just one stage in the overall composition, and you can see how he injected so much more than what his models gave him. He made many adjustments, both major and minor, to accentuate the expressiveness and drama he was after. He was always conscious of the sources of light in his art, too: he was a master of chiaroscuro, brilliantly handling the deepest black shadows and dazzling white highlights. Frequently, he heightened the physicality of his subjects – their twisted, strained faces and bodies wracked by anguished trauma threatening to burst the bounds of the comics' covers.

Rather than creating a clear distinction between the several artistic techniques he used, Cortez instead varied them, choosing whichever best suited his subject and intentions. So, on certain covers, notably those featuring terrified victims, he would opt for a luscious realism and exacting facial and physical precision; this increased the reader's identification with these all-too-human victims, who are often staring out at us wide-eyed with fear. Then he would also combine two painterly registers in the same illustration to create an extreme contrast between human frailty and the ethereal, supernatural realm, sometimes approaching abstraction with his loose, expressive strokes. On some covers, delicate, translucent fabrics barely conceal the bodies they encircle. Sometimes he even coloured and collaged his photographs into his painted locations and scenes of monsters. To my mind, covers such as *O Terror Negro* nos. 61 and 62 and *Sobrenatural* nos. 13 and 22 stand among his most daring experiments (you can see these in *Terrror: the Horror Comic Art of Jayme Cortez Volume 1*). Cortez employs a Dalí-esque exactitude and credibility to plunge us into his own versions of psychological mindscapes that shimmer with symbolism.

So, it is now time to enter and experience the nightmarish oeuvre of Jayme Cortez and give him the long-overdue acclaim he deserves as a truly visionary and versatile master of comic art.

PAUL GRAVETT
London, UK

Opposite: "You will feel the blood run cold in your veins when you read… *Histórias Macabras*", comic advertisement, circa 1960.

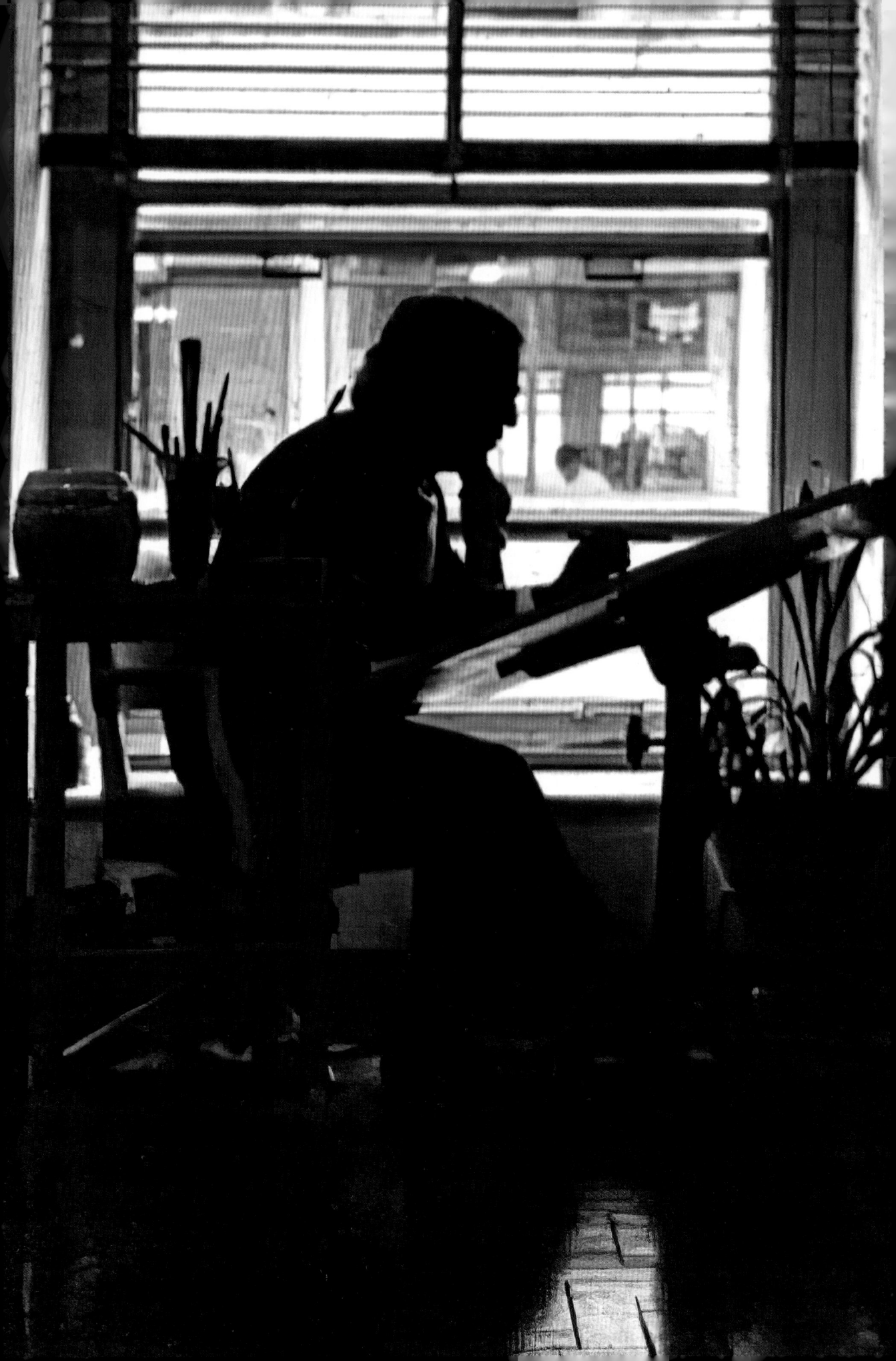

A VIRTUOSO OF ILLUSTRATION

BORN IN LISBON, PORTUGAL, on 8 September 1926, and baptised Jaime Cortez Martins, Jayme Cortez would adopt his artistic pseudonym many years later, after relocating to Brazil. When he was six years old, one of his father's friends gave him some American Sunday newspaper comic strips; the young boy was enthralled by the cartoons and began to draw, attempting to imitate his idol Alex Raymond, the creator of Flash Gordon. In 1937, at the age of 11, Cortez had his first drawing published: a pencil sketch that appeared in *Pim-Pam-Pum*, a children's supplement of the Portuguese newspaper *O Século*.

In 1944, Cortez began an apprenticeship with the children's magazine *O Mosquito* under the tutelage of its art director, Eduardo Teixeira (E.T.) Coelho, who at the time was considered the greatest Portuguese cartoonist. The young artist learned the techniques of comic-strip production and the value of using life models, and often asked his relatives and friends to pose when illustrating stories.

Before long, Cortez had created his first comic strip, *Uma Espantosa Aventura* (An Amazing Adventure), which was followed by *Os Seis Terríveis* (The Terrible Six) and *Os Dois Amigos na Cidade dos Monstros Marinhos* (Two Friends in the City of the Sea Monsters). All of Cortez's stories at this time were set in the streets of Lisbon's historic Bairro Alto district and depicted the lives of the poor children living there. He then turned his hand to westerns with *O Vale da Morte* (The Valley of Death); however, he detested the result, and years later said he considered it his worst work. He returned to

Opposite: Jayme Cortez at his desk in the studio of the advertising agency McCann Erickson in São Paulo, 1970.

Below: *Os Dois Amigos na Cidade dos Monstros Marinhos*. Published in *The Mosquito* no. 733, July 1946.

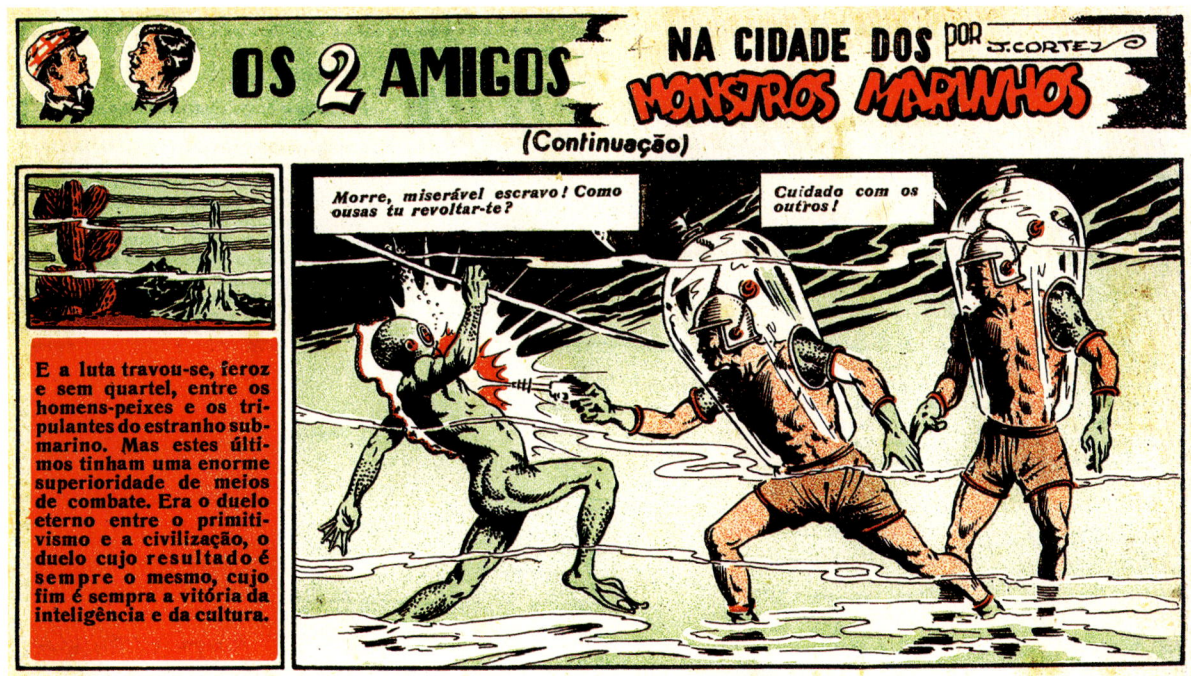

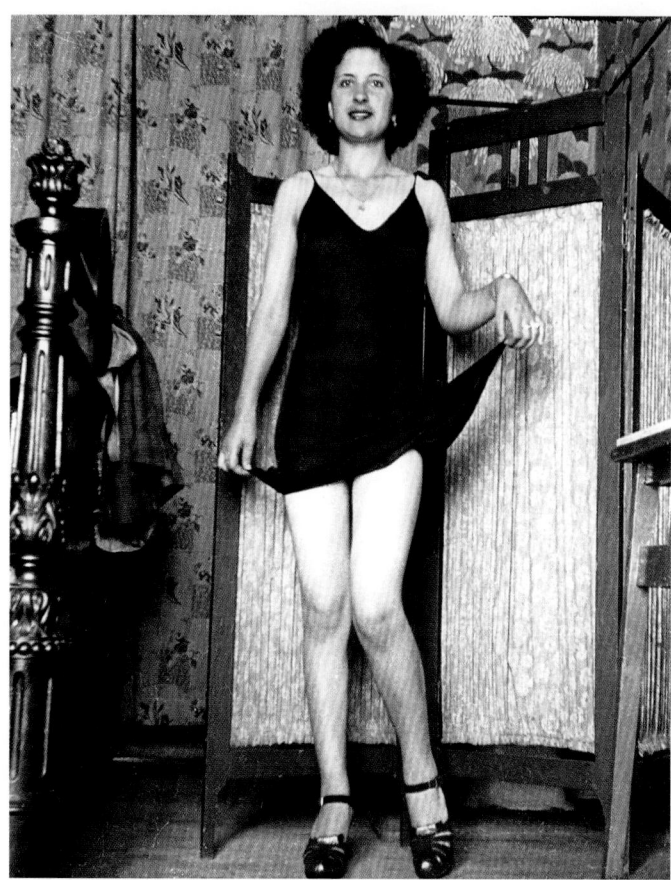

tales of street kids and their adventures in his native Bairro Alto in 1946 with *Os Espíritos Assassinos* (The Murderous Spirits), his final contribution to *O Mosquito*.

While working for *O Mosquito*, Cortez familiarised himself with Brazilian print media, reading newspapers and magazines such as *A Gazeta Juvenil*, *O Tico-Tico*, and *O Globo Juvenil*. He was captivated by the vibrant use of colour in their comic strips and decided that Brazil was the "El Dorado of Comics." At the time, Brazilian comic stories were populated almost exclusively by American characters, leading Cortez to assume there was a lack of illustrators in Brazil. So, in 1947, at the tender age of 21, Cortez migrated to Brazil in search of better job opportunities. He arrived in the South American country full of hope and eager to have his art published. However, as he would later say, his dream of finding an "El Dorado" vanished when he realised that "it was cheap to import foreign content to Brazil, which made it difficult for artists based in Brazil to make a living."

However, Cortez persisted and found his first job in his new home, producing political cartoons for the São Paulo newspaper *O Dia*. Not long after, *Caça aos Tubarões* (Shark Hunt), a comic strip of his own creation, was published in the newspaper *O Diário da Noite*. He then adapted the renowned Brazilian novel *O Guarani* (The Guarani), by José de Alencar, into a daily comic strip. Some claim that Cortez's adaptation of *O Guarani* was the first daily strip drawn and published in Brazil, which, if true, would mean Cortez played a pivotal role in the development of Brazilian comics.

In 1948, Cortez met and fell in love with a beautiful woman called Maria Edna; the couple were soon married. With his already evident talent galvanised by his new relationship, he found a job as an illustrator at São Paulo's *A Gazeta Juvenil*, one of the Brazilian publications he had read back in Portugal. His boss at the paper was the veteran cartoonist Messias de Mello, thought by many to be one of the greatest Brazilian illustrators. Under Messias' wing, Cortez studied, among other things, new ways of using colour and composition. He illustrated stories, drew vignettes, and produced humorous cartoons, caricatures, and several comics for the paper. When *A Gazeta Juvenil* folded in the mid-1950s, Cortez, by then reasonably experienced, found work with the La Selva publishing house as a freelance illustrator. At first he produced covers for La Selva's humour magazines, but, recognising his talent, the publisher quickly put him in charge of the artwork for all their publications. He could work extremely quickly, and was able to produce a cover in a day – from the initial layout to the

Above left: Detail of *Os Dois Amigos na Cidade dos Monstros Marinhos* (Two Friends in the City of the Sea Monsters), *The Mosquito* no. 752, 1946.
Above right: Model posing for *Os Dois Amigos na Cidade dos Monstros Marinhos*, *The Mosquito*, 1946.

final artwork. La Selva was the first publisher in Brazil to publish horror comics, and it was with the groundbreaking magazine *O Terror Negro* (The Black Terror) that Jayme Cortez attained huge success as a specialist in horror illustration, achieving a level of artistry rarely matched by his contemporaries. Among the other horror comics he illustrated for La Selva were *Contos de Terror* (Tales of Terror), *Clássicos de Terror* (Horror Classics), and *Sobrenatural* (Supernatural).

The charming Portuguese cartoonist made a lot of friends following his arrival in Brazil; among them was Miguel Penteado, who worked in the photographic laboratory where Cortez developed the reference photos for his illustrations. Penteado, who had long been interested in drawing, became Cortez's mentee; he followed his friend's pointers on illustration and soon left his job to dedicate himself full-time to drawing and illustration.

In 1951, Cortez and Penteado, along with Álvaro de Moya, Reinaldo de Oliveira, and Syllas Roberg, organised the historic Primeira Exposição Internacional de História em Quadrinhos (First International Exhibition of Comics), held in São Paulo. Today, this convention is recognised as a watershed moment in the history of comic books, taking place several years before European scholars began to show an interest in the genre. At the exhibition, the young organisers displayed original works from great North American artists such as Alex Raymond, George Herriman, Milton Caniff, Al Capp, and Hal Foster. Also on display were reproductions of seminal magazines and stories. Additionally, they held workshops on the creation and development of comic strips, analysed Will Eisner's character The Spirit, criticised publishers and the plagiarism among Brazilian authors, challenged the marginal status attributed to comic art, and advocated for greater recognition of Brazilian cartoonists. In the years that followed, Cortez would help organise several other events in Brazil and around the world dedicated to promoting and discussing comic strips. In addition, the year 1951 also saw the birth of his first son, Leonardo Cortez.

In 1953 Cortez produced covers for the magazines *Misterix* and *Raio Vermelho*, from the publishing house Abril, and illustrated magazine covers for the Aliança Juvenil publishing house. He also launched his character Sérgio do Amazonas (Sergio of the Amazon) for the Bentivegna publishing house in São Paulo. It would be republished some 30 years later in Portugal in the 1984 *O Mosquito Almanaque*. Cortez shared the Aliança Juvenil work with his friend Miguel Penteado, with Cortez handling the composition and the drawing and Penteado taking care of the inking and colouring. As both men still worked for La Selva, they decided to adopt a collaborative pseudonym and sign the Aliança Juvenil covers "FACO": "FA" for Miguel Falcone Penteado and "CO" for Jayme Cortez.

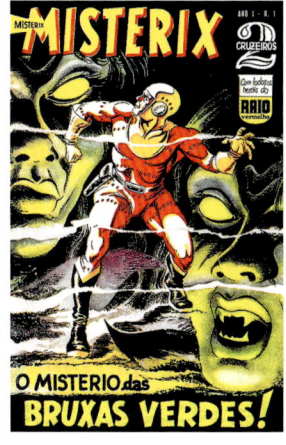

Above: *Misterix* no. 1, 1953, Abril.

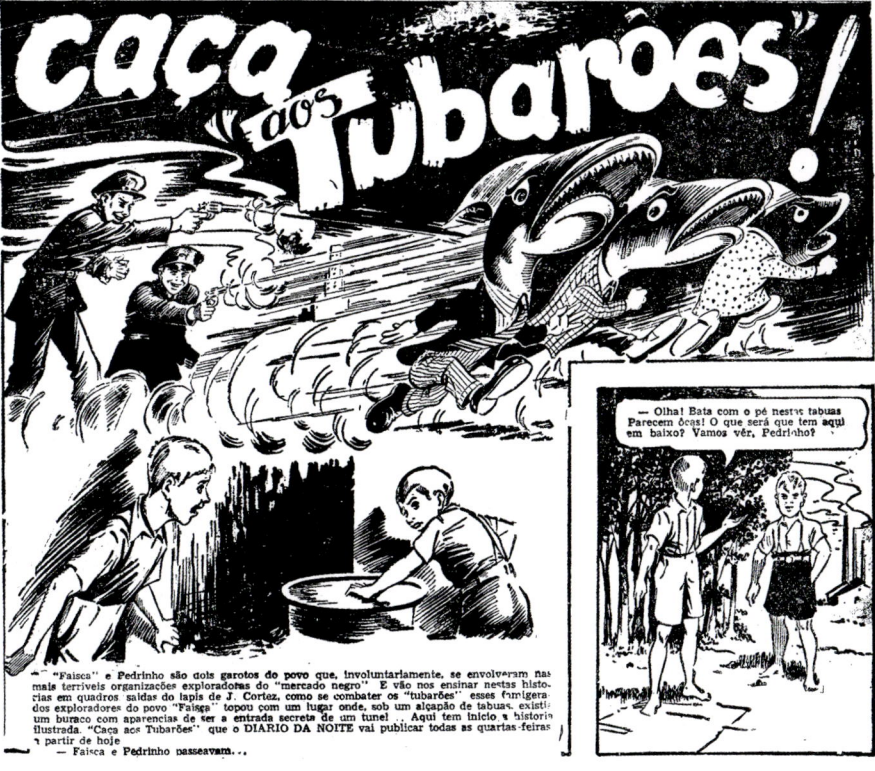

Left: The *O Diário da Noite* newspaper strip *Caça aos Tubarões* (Shark Hunt), April 1947.

A VIRTUOSO OF ILLUSTRATION | 15

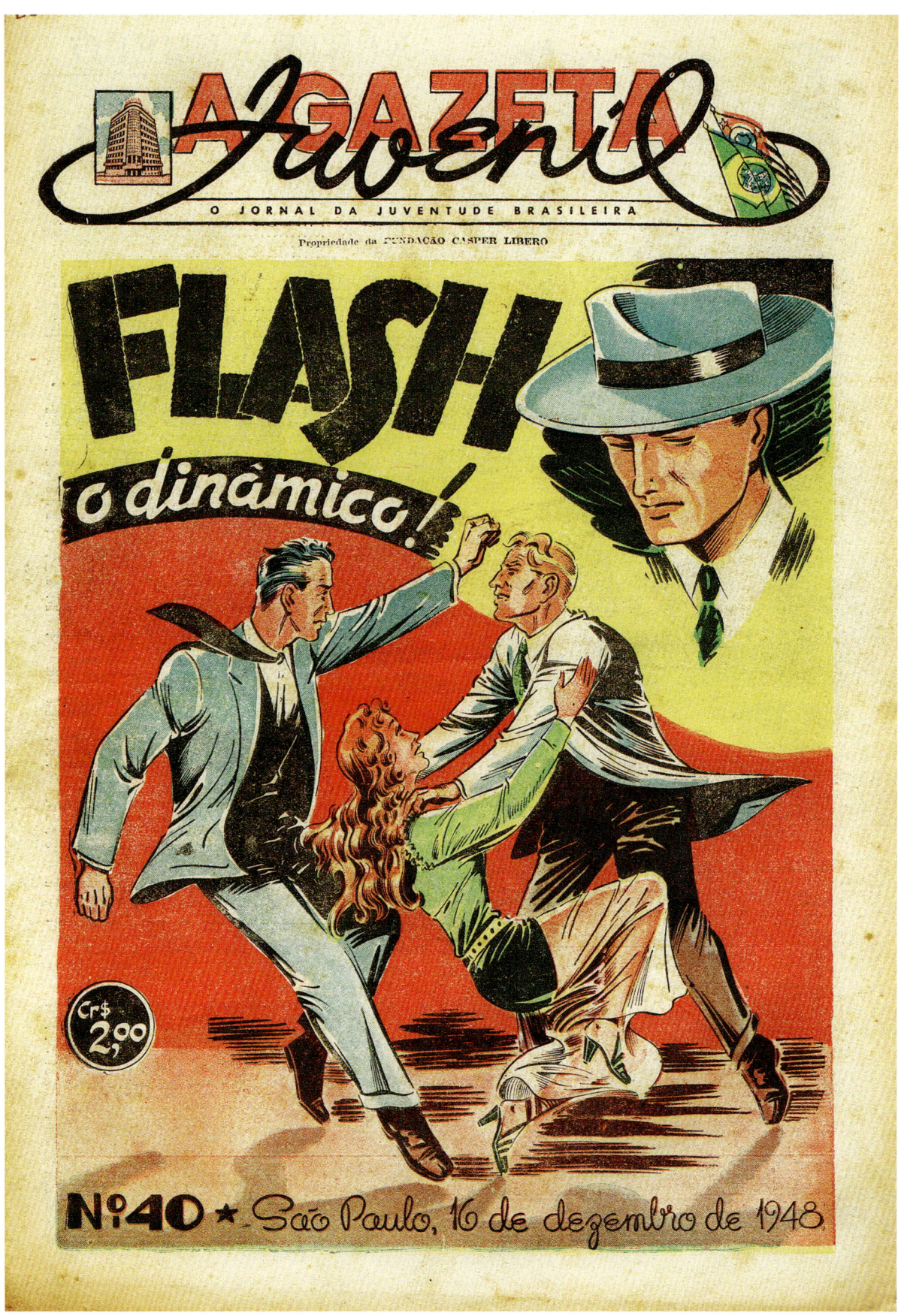

Above: Cortez's cover for *A Gazeta Juvenil*, December 1948.

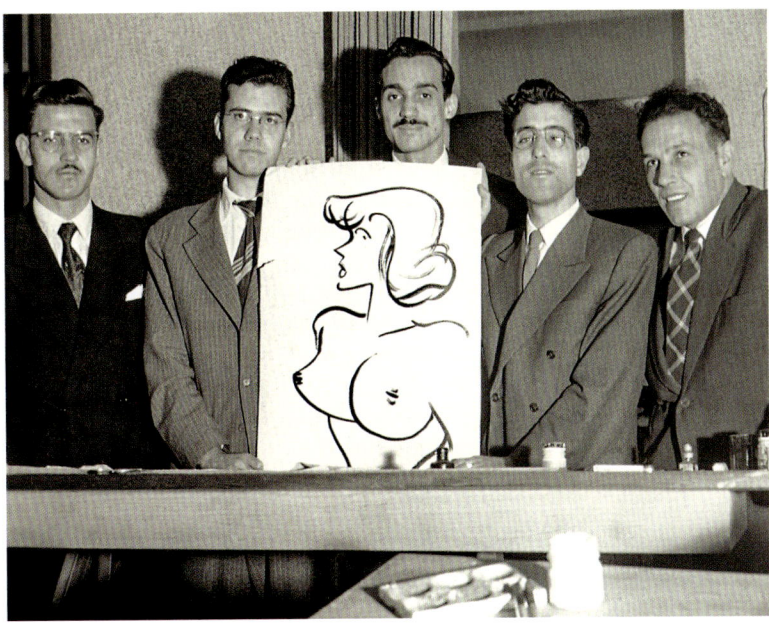
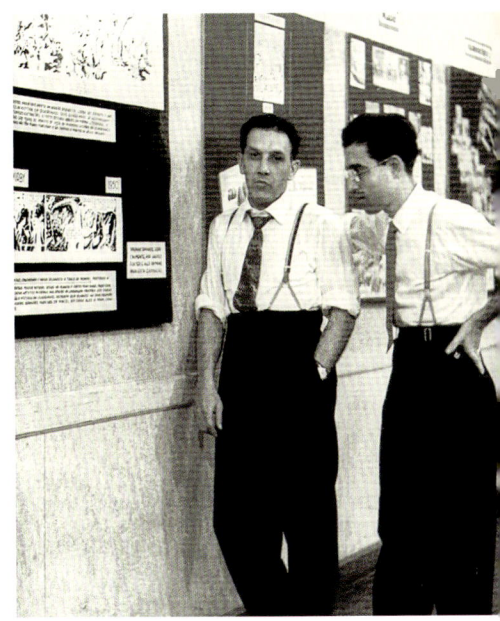

In 1956, Cortez published his first children's comic strip, featuring the indigenous boy Tupizinho and his adventures in the Brazilian jungle, for La Selva. He became a naturalised Brazilian in 1957, and the following year began another important phase in his career by branching out into movie poster illustration. Two years later, in 1959, he left La Selva to become a partner at another publisher, Continental, together with Miguel Penteado; in May or June 1960, for reasons that are shrouded in mystery, Continental changed its name to Outubro (October). Outubro included the following information on all their magazine covers: "100% written and drawn in Brazil." Although he was the art director at Outubro, Cortez continued to work with La Selva as a freelancer, producing covers for children's magazines.

While at Outubro, Cortez launched countless hugely successful magazines, for which he created the majority of the covers. During his time at La Selva, Cortez had always supported emerging artists, and he made a point of continuing this practice at Outubro, giving opportunities to aspiring illustrators and storyboarders, some of whom became icons of Brazilian comic book art and illustration. For example, he gave the talented young Brazilian artist Mauricio de Sousa the opportunity to publish his first comic book, *Bidu*. Sousa would later attain global renown for his children's characters in the series of comic books *A Turma da Mônica* (Monica's Gang).

While Cortez painted the magazine covers at Outubro, his partner, Miguel Penteado, ran the company's printing shop and created covers only occasionally. The pair decided that Cortez would sign some covers M. Penteado, to make it appear that Outubro had more than one illustrator on its books. Eagle-eyed readers will find those covers in this book. In 1961, Cortez published a title that came to be considered his masterpiece of the horror comic genre: *O Retrato de Mal* (The Portrait of Evil); see pages 27–39. Cortez decided to leave Outubro in 1964 due to conflict between the company's partners, but he would continue to collaborate with La Selva.

When the Escola Panamericana de Arte (Pan-American School of Art) opened in São Paulo in 1965, Cortez was hired to teach classes in illustration and comic-strip production; the school's brochure portrayed him as one of the most prolific and eminent illustrators in the country. He released his how-to drawing book *A Técnica do Desenho* (The Technique of Drawing) the same year. It was a huge success and was followed by two more titles: *Manual Prático do Ilustrador* (The Illustrator's Practical Handbook) and *Mestres da Ilustração* (Masters of Illustration). These trailblazing texts brought Cortez even greater esteem as an artist.

Cortez also began working in Brazilian television in 1965, producing title sequences for soap operas. Meanwhile, he was invited to art direct the radio and TV department of McCann Erickson, one of the largest advertising agencies in Brazil and the world at the time. While working there, he tirelessly continued to promote Brazilian comics. He started on the path to international recognition in 1966 by attending the Salone Internazione dei Comics (International Congress of Comics) in Lucca, Italy, for the first time, an event to which he would return several times as a member of the

Above left: Tito Silveira, Álvaro de Moya, Lindbergh Faria, Jayme Cortez, and Miguel Penteado of *A Gazeta Juvenil*, 1948.
Above right: Miguel Penteado and Jayme Cortez at the Primeira Exposição Internacional de Quadrinhos, 1951.

Above: The publishing house Outubro's logo.

A VIRTUOSO OF ILLUSTRATION | 17

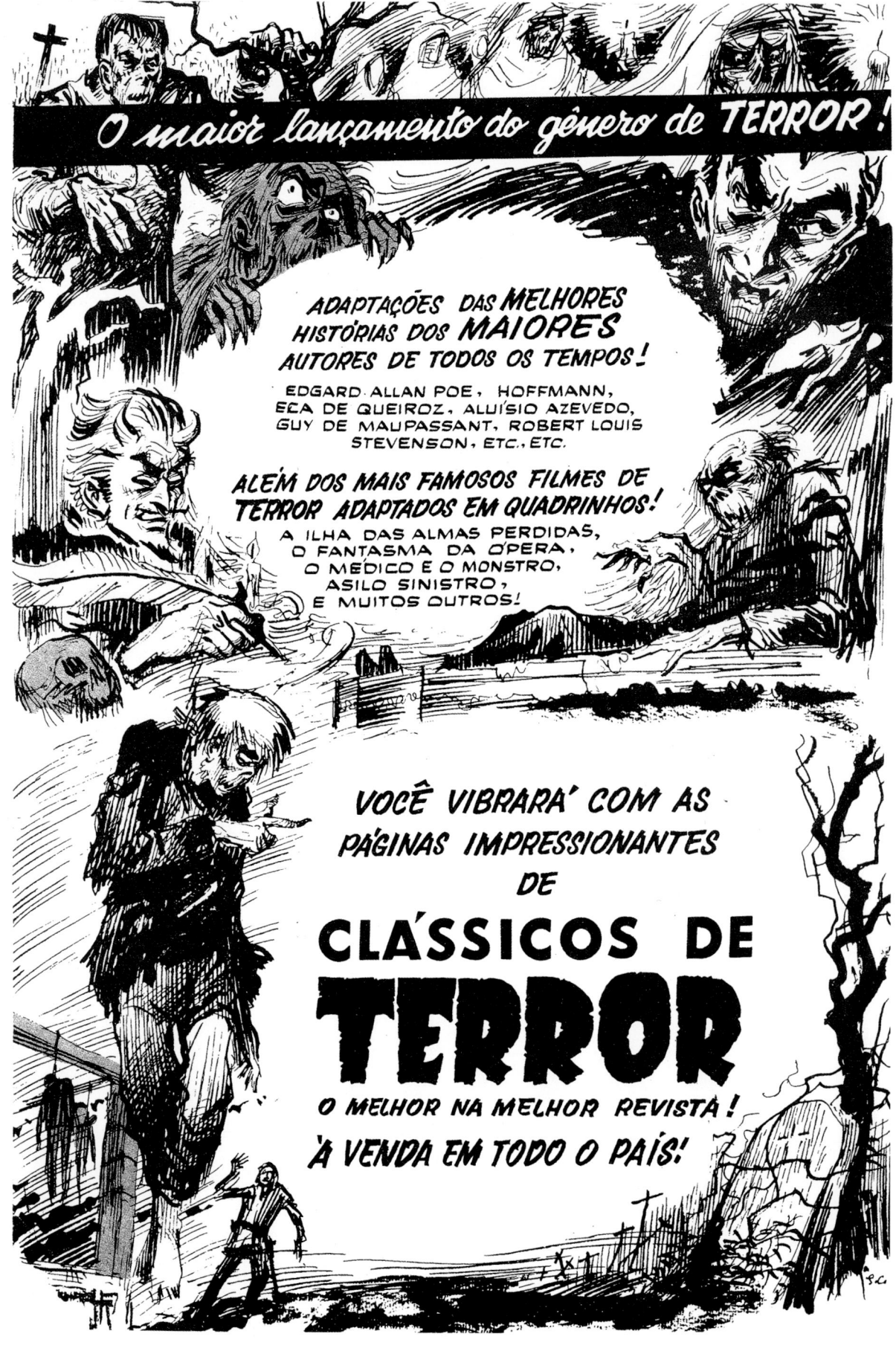

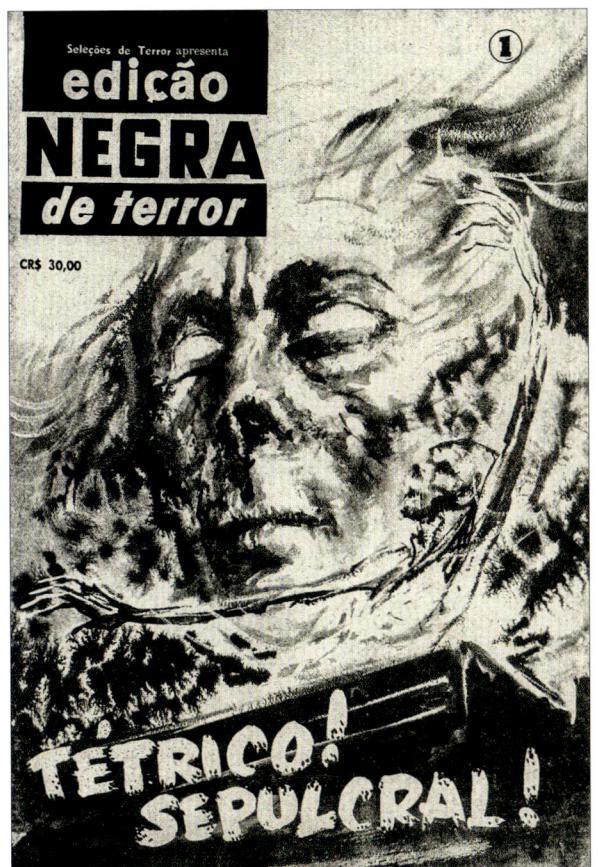
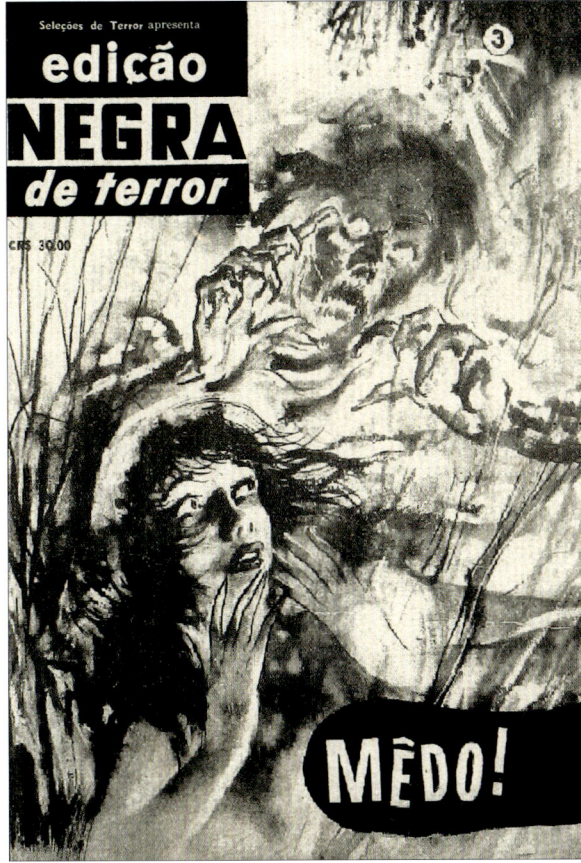
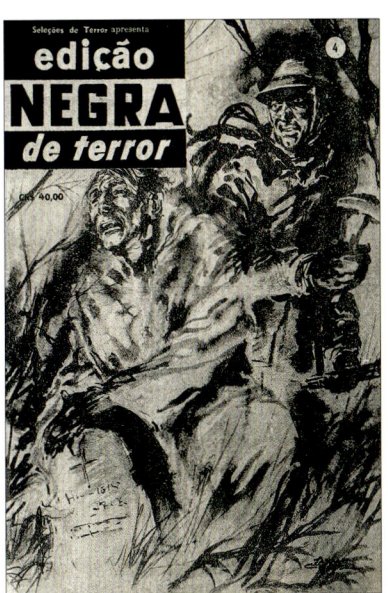
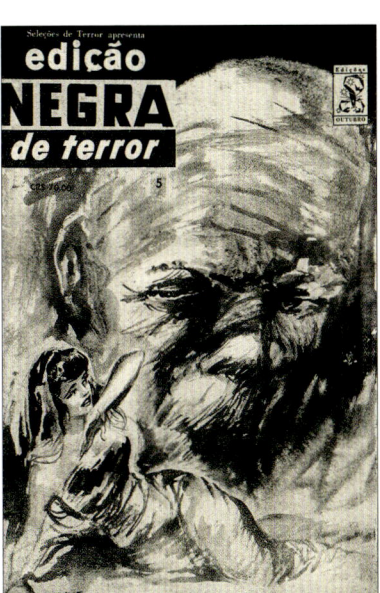
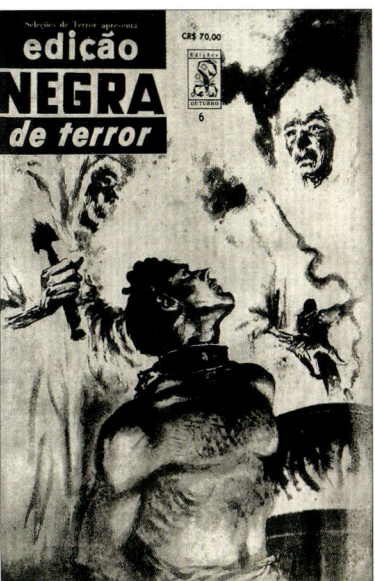

Above: *Edição Negra de Terror* (Black Edition of Terror) was published by Outubro in 1964 and ran for six issues. To save costs, the cover and interior pages were printed on the same paper in black and white; however, the paper was of such poor quality that the covers failed to protect the pages, and the entire magazine soon became dilapidated, making surviving copies rather rare. Cortez painted the monochrome covers using Indian ink.

Opposite: Comic book advertisement for *Clássicos de Terror* (Horror Classics), 1961, Outubro.

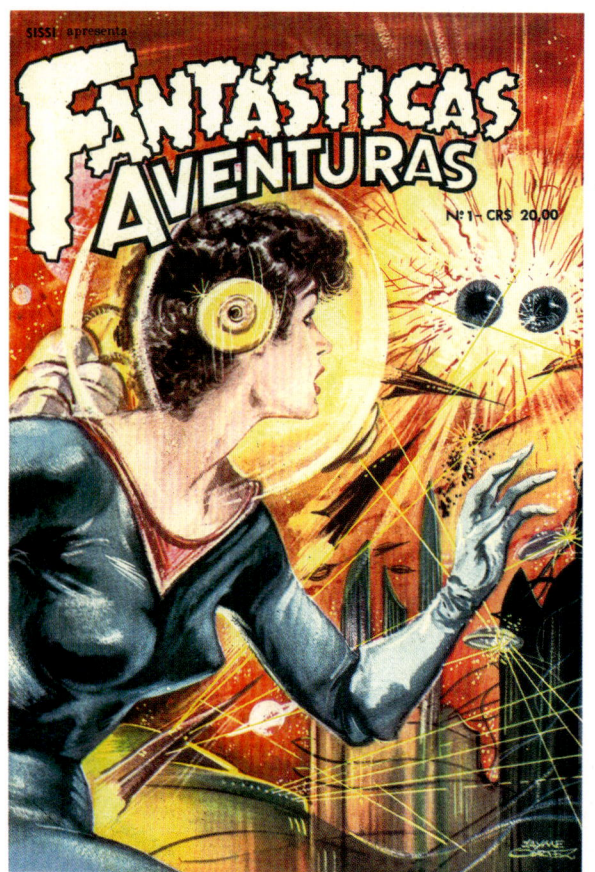
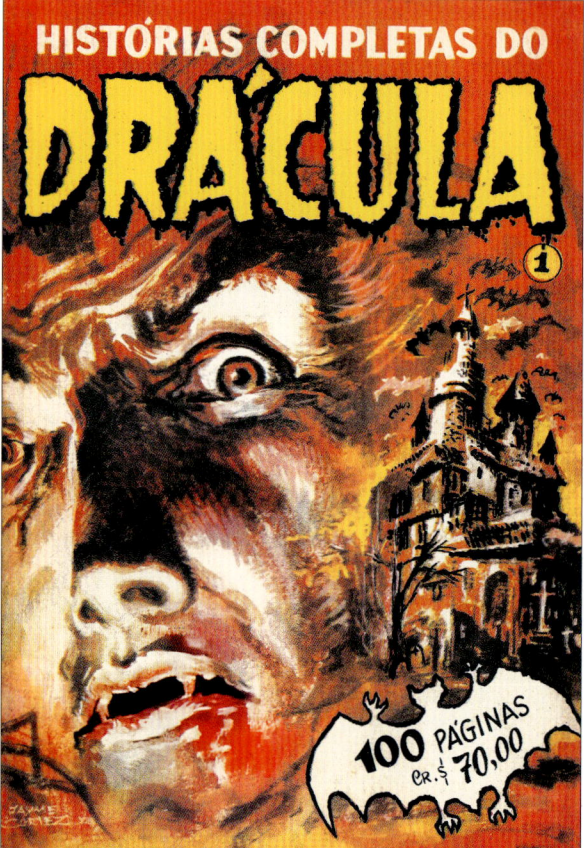

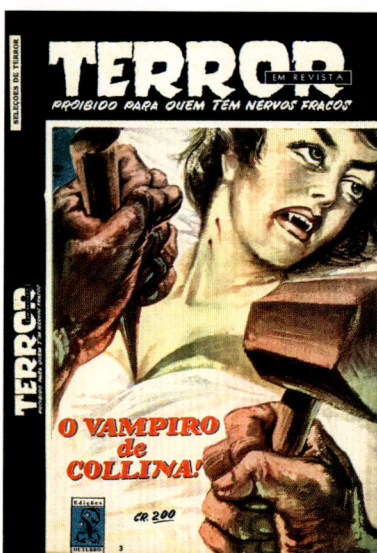
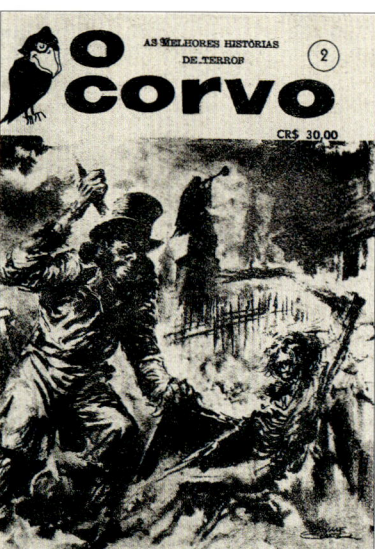

Clockwise from top left: *Fantásticas Aventuras* (Fantastic Adventures) no. 1, 1961, Outubro. *Fantásticas Aventuras* ran for 12 issues and Cortez only illustrated two issues; *Histórias Completas do Drácula* (Complete Dracula Stories) no. 1, Outubro; *O Corvo* no. 2, 1964, Outubro; *Terror em Revista* (In Terror magazine), Outubro; *Fantásticas Aventuras* no. 48, 1961, Outubro.

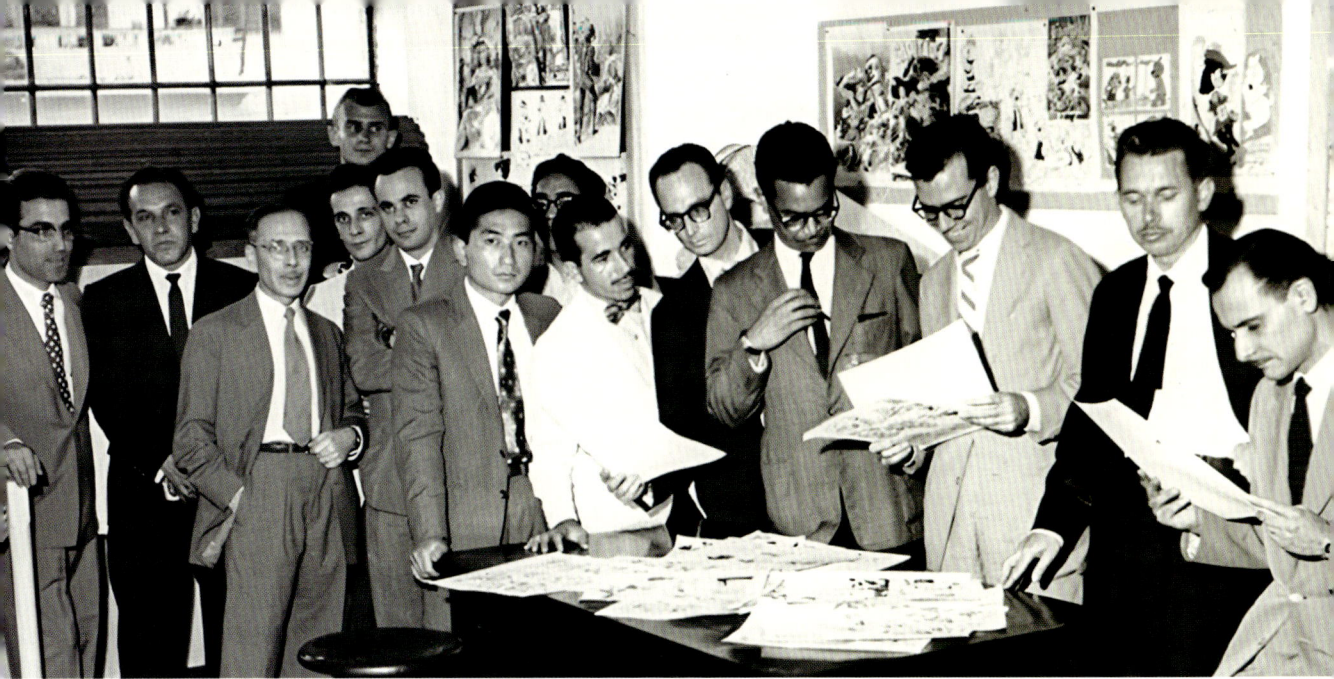

Above: Jayme Cortez and Miguel Penteado (far left) and the staff of Outubro.

Brazilian delegation. He also represented Brazil at several other international comic book conventions, in Buenos Aires (I Bienal Mundial de La Historieta [First World Biennial of Comic Strips]), Córdoba (I Bienal Internacional e IV Bienal Argentina de Humor e Historietas [First International Biennial and the Fourth Argentinian Biennial of Cartoons and Comic Strips]), New York (First American International Congress of Comics), and Angoulême (Salon Internationalle de la Bande Dessinée [International Comics Festival]). He continued to represent Brazil at international events, gaining global acclaim and recognition. In 1967, his second son, Jaime Cortez Filho, was born.

In 1973, Cortez produced the second version of his most famous horror comic, *The Portrait of Evil*. The reworked story was published in the second issue of the magazine *Crás!* from the publishing house Abril, and served as a precurser to his most celebrated work, *Zodiako*, the debut of which in *Crás!* attracted intense interest from the Brazilian media. Cortez's heroic character would go on to take the comic book world by storm; in 1975, Cortez was honoured by having Zodiako appear in a calendar published by the UN's World Health Organization; the comic *Zodiako* also swept the board at that year's comic book award ceremonies in Brazil.

In 1976, after leaving McCann Erickson, Cortez was hired as director of animation and merchandising at his former protegee Mauricio de Sousa's production company, Mauricio de Sousa's Produções, where he made significant contributions to various projects, including the launch of a comic book starring Brazilian football icon Pelé. He returned to the horror genre in late 1976, producing covers for the magazine *Um Passo Além* (One Step Beyond) from the publisher Ideia Editorial. Then, in 1978, he contributed illustrations, comic strips, and articles for *O Grande Livro do Terror* (The Great Book of Horror) from the publishing house Argos. During this period, Cortez enjoyed numerous visits from artist friends from Brazil and abroad, including Will Eisner, Joe Kubert, and José Luis Salinas.

During the 1980s, the indefatigable artist played a leading role in countless comic book conventions and exhibitions. In 1981, he held a solo exhibition covering his whole career, which was made into a documentary about his life and work with the somewhat long-winded title *As Aventuras e Desventuras de um Português em Terras Brasileiras* (The Adventures and Misadventures of a Portuguese Man in Brazilian Lands). Refusing to fade into obscurity, he helped found the Clube dos Ilustradores do Brasil (Illustrators' Club of Brazil) in 1982, becoming its first president. He also made illustrations for the supplement *D.O. Leitura*, published by the Imprensa Oficial de São Paulo. That year he also began to collaborate with the publisher D'Arte, working on their horror comics *Calafrio* (Shiver) and *Mestres do Terror* (Masters of Horror); the relationship would last for several years.

In 1983, publisher Noblet produced the second version of *Tupizinho* in two volumes, complete with colour illustrations; and later that year, Cortez created illustrations for a series of successful Sherlock Holmes books. In 1984, he published several illustrations and two horror stories in the magazine *Inter-Quadrinhos* (Inter-Comics) from the publishing house Ondas. In 1985 he illustrated the magazine *Ação Policial* (Police Action) for Abril and collaborated with Ática as a children's illustrator; in the following year he created storyboards for various advertising agencies.

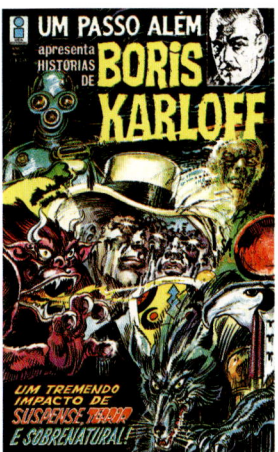

Above: *Um Passo Além* no. 1, 1978, Ideia Editorial.

A VIRTUOSO OF ILLUSTRATION | 21

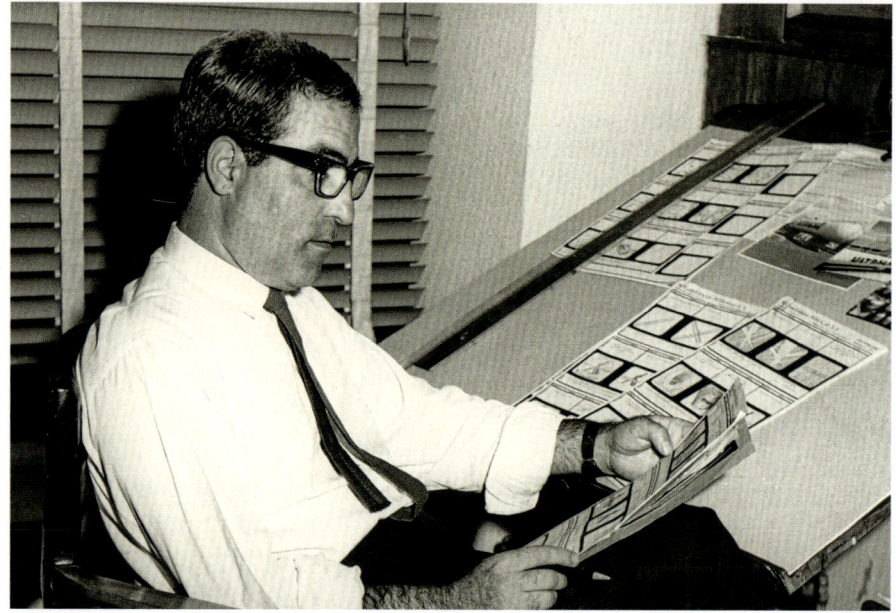

Left: Cortez at McCann Erickson in 1965.

Opposite: Full-page artwork from *Rock in Quadrinhos* (Rock in Comics), Ondas, 1984, in which Cortez illustated a comic adaptation of the heavy metal song "Bark at the Moon" by Ozzy Osbourne.

Cortez's international reputation was cemented in 1986 at the 20th edition of the International Congress of Comics in Lucca, Italy, where he was awarded the world's most coveted illustration prize, the Caran D'Ache; his close friend Will Eisner also received the same award for a life dedicated to comics, while the publisher Press Editorial unveiled *A Arte de Jayme Cortez* (The Art of Jayme Cortez), a magazine covering the artist's entire career. To celebrate Cortez winning the Caran D'Ache, the Pan-American School of Art organised a comprehensive retrospective of his work later that year. In mid-1987, Cortez was hired by the publisher Martins Fontes to work on a book of horror stories. Unfortunately, he would not see the fruits of his labour as, while still highly productive and active, he suffered a serious health issue and passed away on 4 July 1987.

Cortez was a highly gifted artist and the recipient of countless awards. Throughout his career he selflessly shared his experience and knowledge with younger generations of artists in various fields. Fabio Moraes, the official curator of Cortez's collected artwork, has assumed responsibility for preserving his legacy; the artist's work is being protected and disseminated via exhibitions and publications, both in Brazil and Europe. Also crucial to these efforts is Skye Ott's work with Komic Kazi International, which seeks to raise awareness of the significance of Brazilian comics and make available thousands of rare images from international comics (see www.flickr.com/photos/komickaziinternational). From 2023, the Jayme Cortez collection will be incorporated into Portugal's Museu de Banda Desenhada de Beja (Beja Comics Museum) under the custodianship of Fabio Moraes. Cortez lives on in his art, in the influence of his work, and in the thoughts of his friends.

Below left: Jayme Cortez with Marvel's Stan Lee, New York, 1972.
Below right: Cortez in his studio with Will Eisner, 1980.

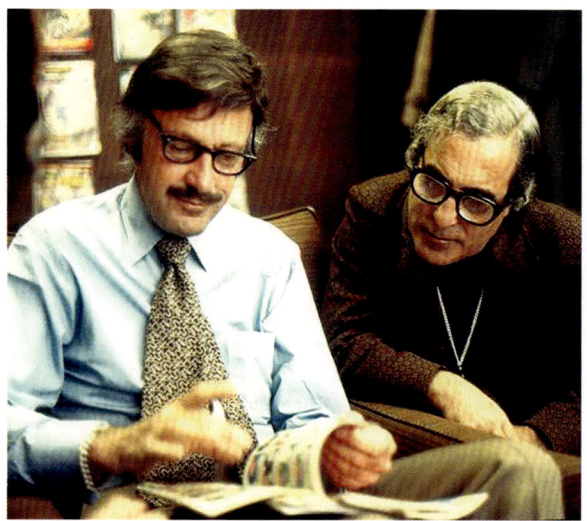

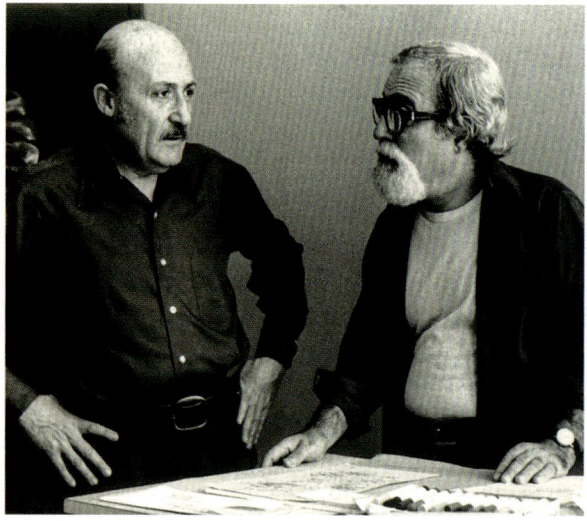

22 | A VIRTUOSO OF ILLUSTRATION

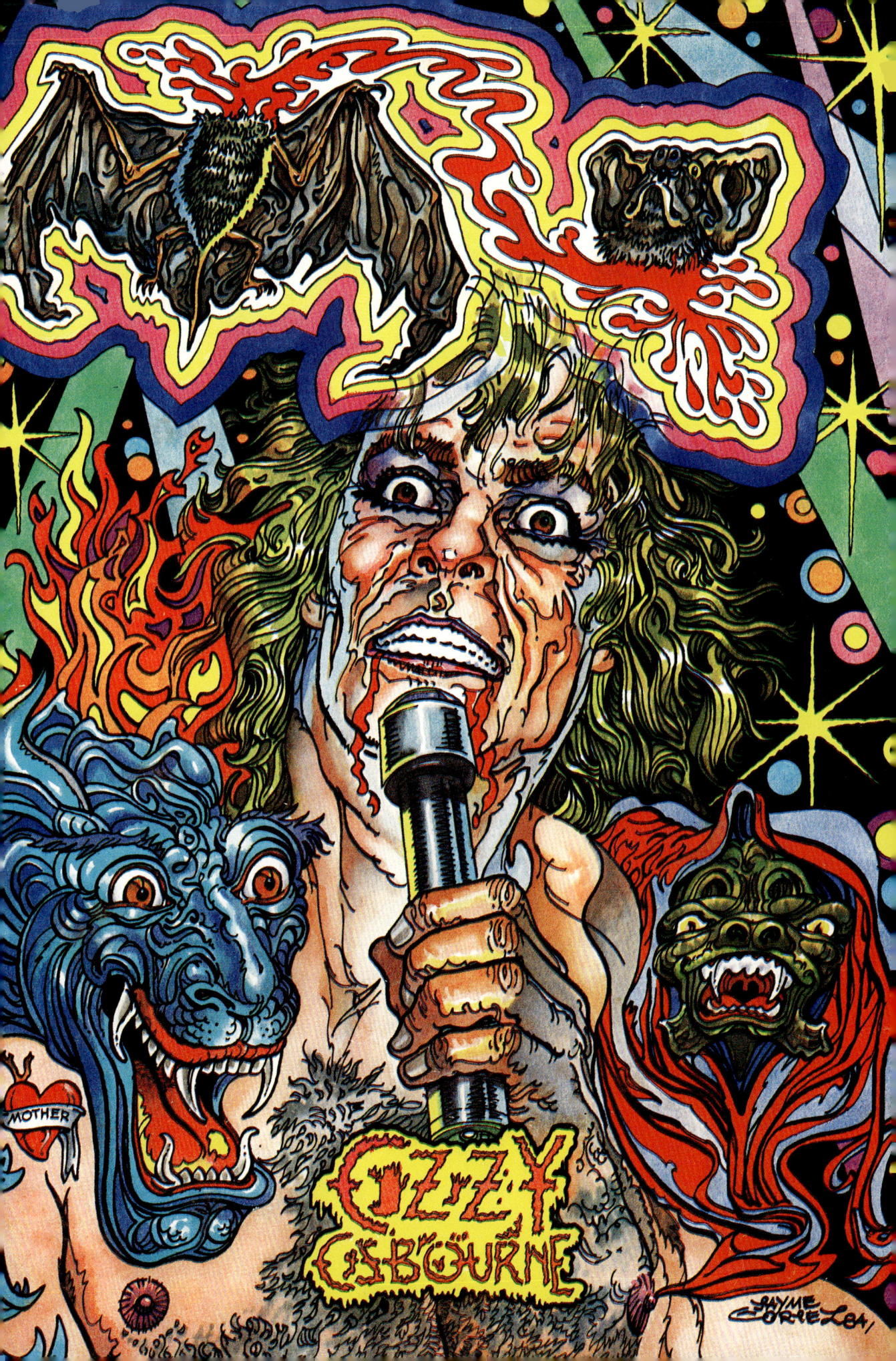

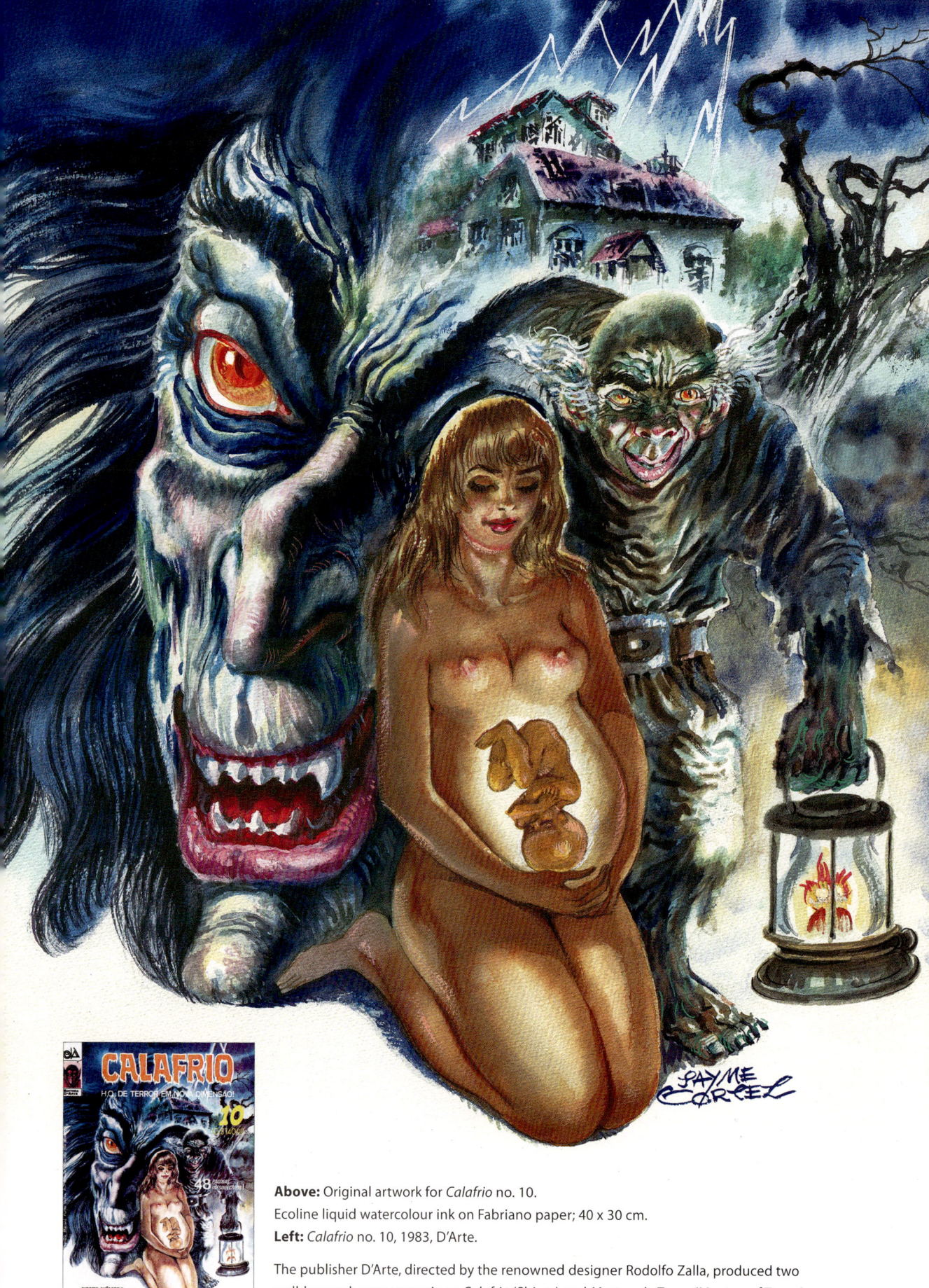

Above: Original artwork for *Calafrio* no. 10.
Ecoline liquid watercolour ink on Fabriano paper; 40 × 30 cm.
Left: *Calafrio* no. 10, 1983, D'Arte.

The publisher D'Arte, directed by the renowned designer Rodolfo Zalla, produced two well-known horror magazines: *Calafrio* (Shiver) and *Mestres do Terror* (Masters of Terror). Both titles started in 1981 and would go on to feature some of the best artists of the 1980s.

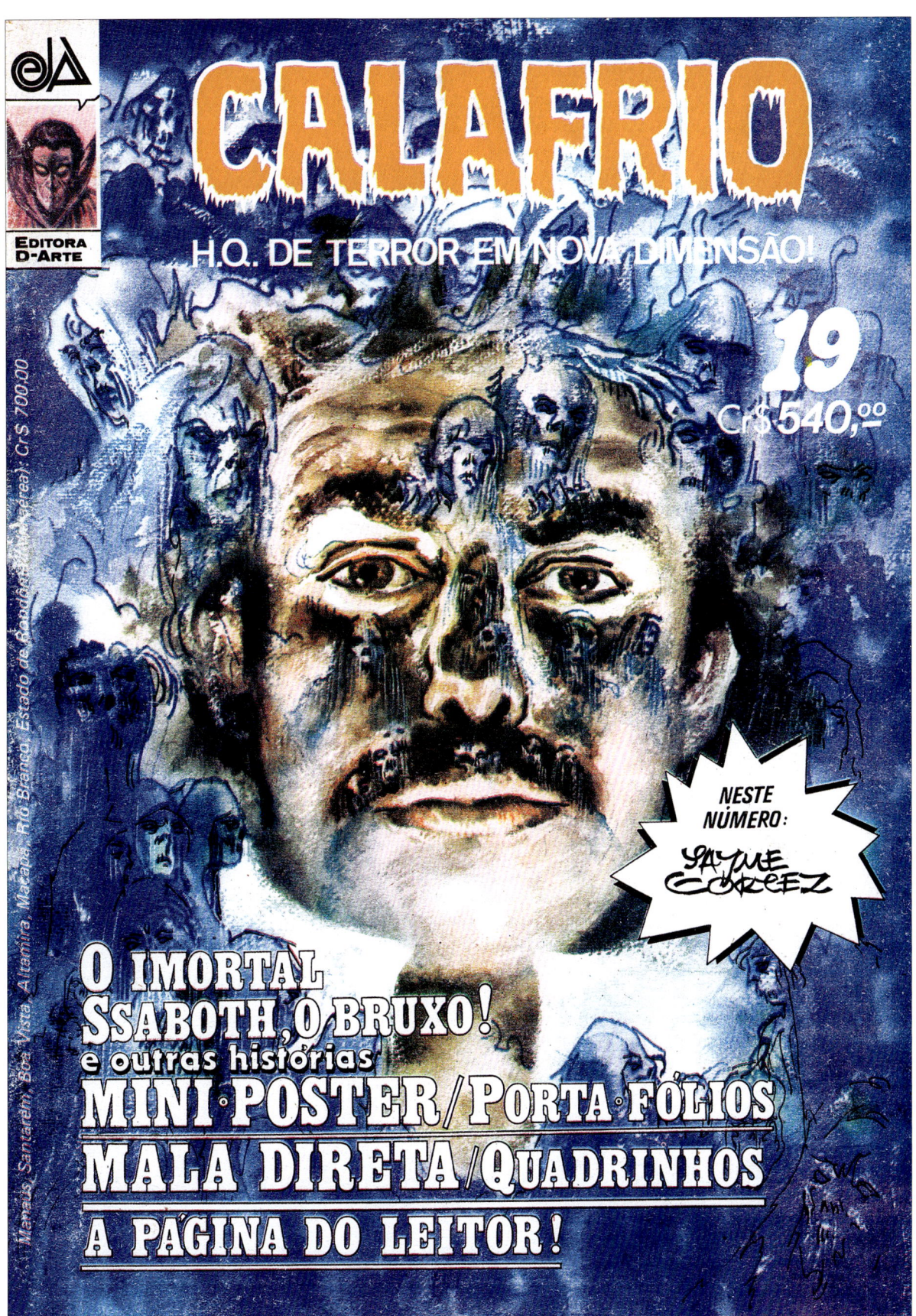

Above: *Calafrio* no. 19, 1983, D'Árte. A special issue dedicated to Jayme Cortez; at the time, it was extremely unusual for a magazine to honour an artist in this way.

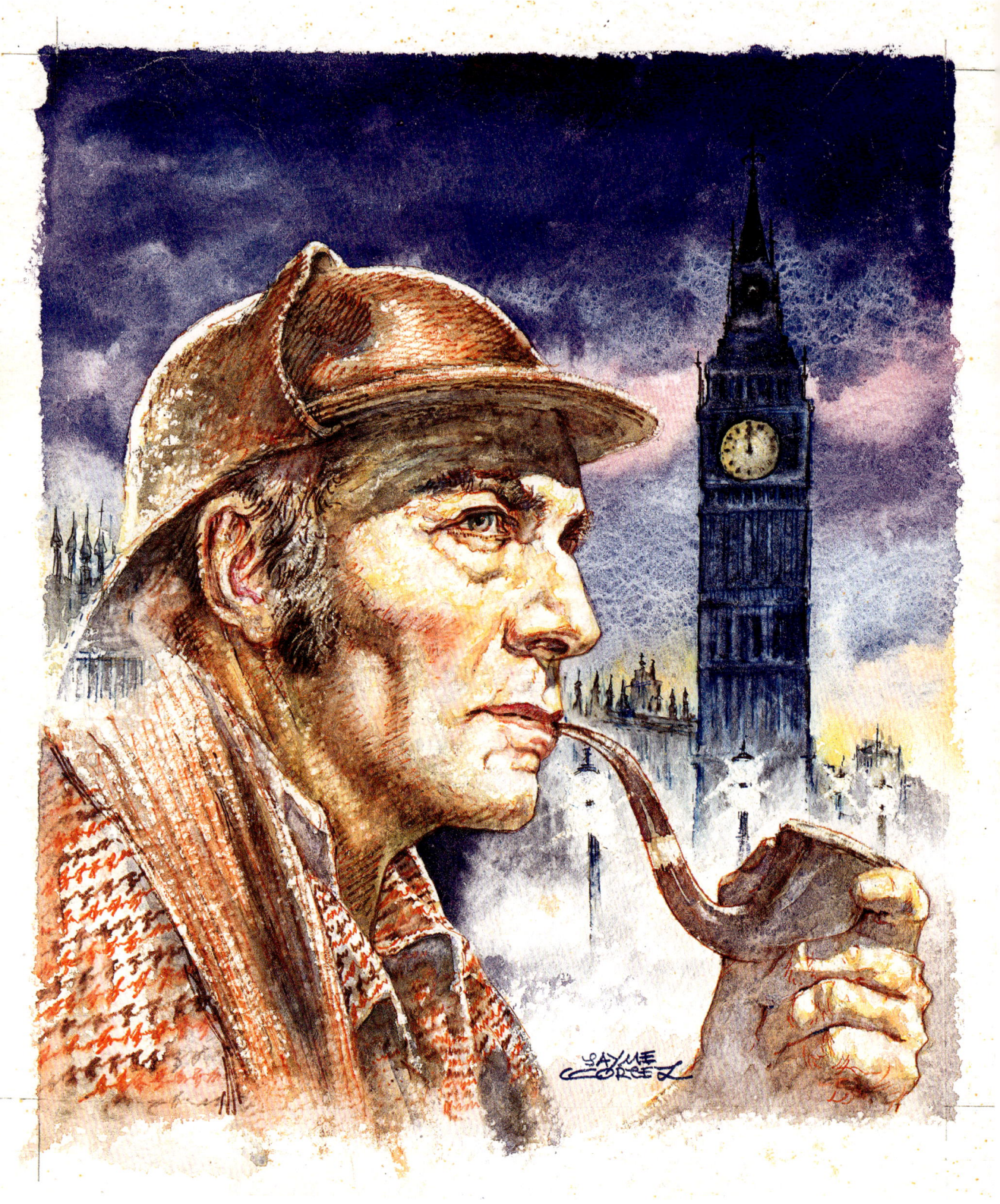

Above: Illustration for the cover of *Sherlock Holmes* no. 1, 1983, Editora Fittipaldi.

THE PORTRAIT OF EVIL 1961

HE 1960s WERE THE GOLDEN AGE of horror comics in Brazil, and it was in this decade, in between painting covers, that Jayme Cortez penned a horror comic strip that would become one of his most famous works: *The Portrait of Evil*. The strip, just three pages long, was illustrated in classic Baroque style and told the story of a cursed artist who, in his efforts to paint a masterpiece, evoked the wrath of an evil presence from beyond the grave.

The Portrait of Evil was an instant success, earning Cortez even greater acclaim as a comic book artist. His highly elaborate illustrations, finished with dip pens, turned each page of the strip into a genuine work of art. Curiously, the protagonist bore a resemblance to Cortez in his later years.

Cortez created his comic books by first assembling a storyboard, which he would subsequently break down into several numbered sections, each corresponding to an individual panel. Next, he would start to sketch out the story, making quick pencil drawings. By the time he reached the narrative composition phase, he would have researched and decided on the elements that would appear in each scene of the strip. As Cortez himself put it, "The basis of a comic's narrative language is the technique of cinematographic découpage. The author's eyes are the camera's point of view, with its optical resources and movement. Long shots and the counteracting close-ups, changes of perspective, panoramic views of the subject in focus, cuts and image counterpoints are all part of the lexicon of comic book art."

An incessant innovator, Cortez created the revised (1973) edition of *The Portrait of Evil* on an A2 layout sheet, using a grid that set out every possible composition for each page – a method that proved highly effective for finding the best layout. He placed the grid beneath the paper on which he would draw the pencil sketch, and then moved to the light table to organise the comic strips according to the prepared sketches. With the comic strip now structured and all the elements prepared, he began the detailed pencil drawings on a layout pad, always making them two or three times larger than the final format. Drawing on this grander scale enabled Cortez to produce effects that could only be perceived when the original artwork was scaled down from its original size for publication. Cortez said, "To create the right atmosphere for horror comics, the artwork had to be heavy, twisted, hazy, and imprecise."

Throughout his long career as an illustrator, Cortez honed a technique that allowed him to work rapidly – he would draw the characters in pencil and sketch the background scenes, only finishing these later. After completing the pencil drawings, he began the process of lettering the story, filling in the speech bubbles and drawing titles and onomatopoeias (words that suggest a sound) using a sheet of Schoeller paper on a light table. Then, still on the light table, he would begin to apply the Indian ink, drawing frame by frame. Rather than simply slathering his drawings with ink, Cortez employed his command of the brush and pen to produce highly idiosyncratic works of art, wielding his versatile Gillot dip pen to execute a wide array of effects.

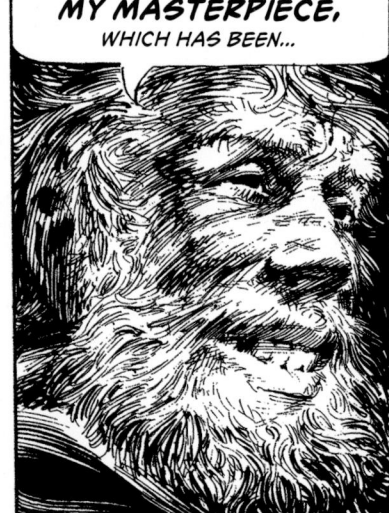
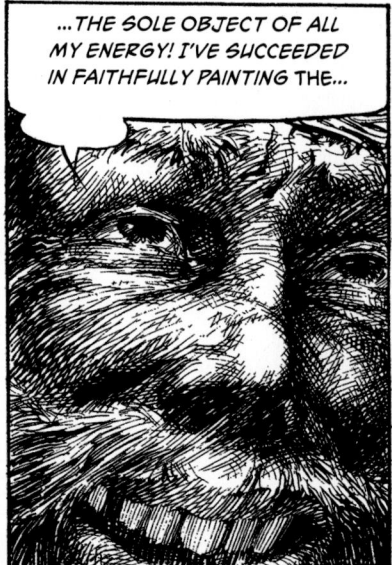

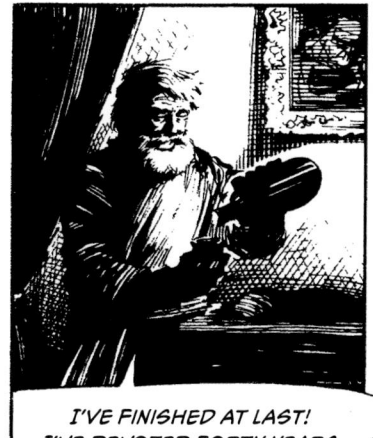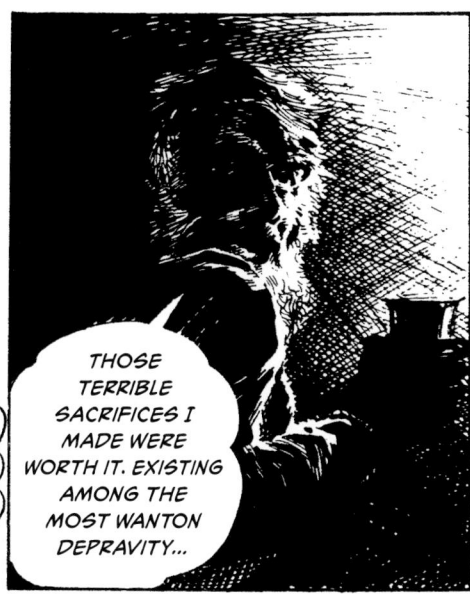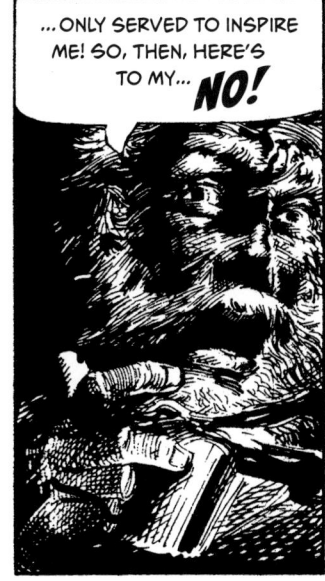

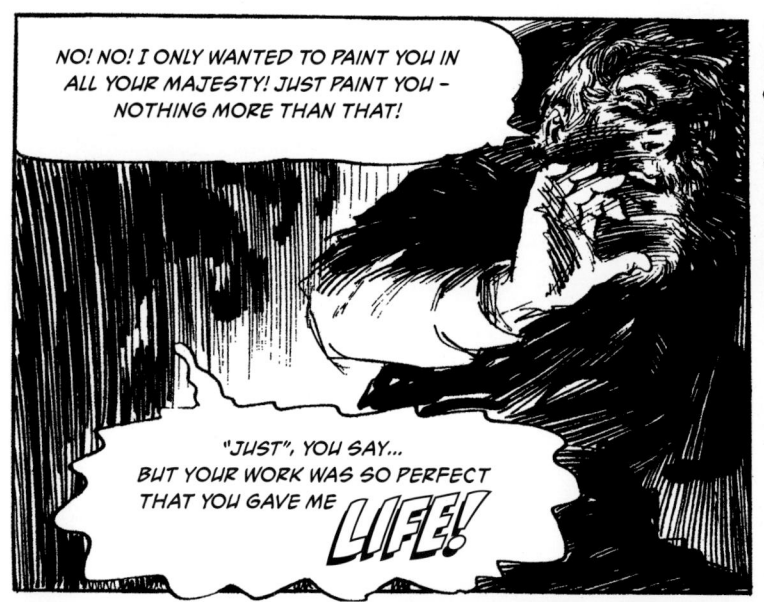
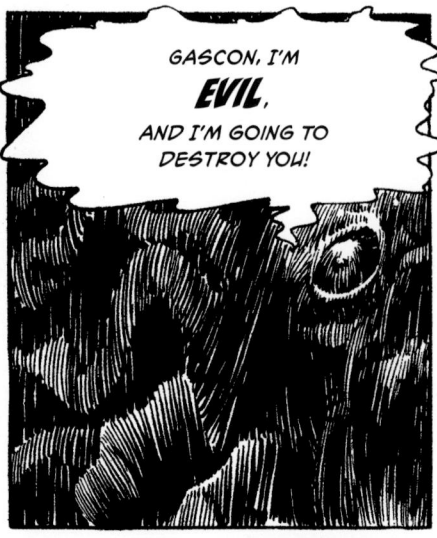
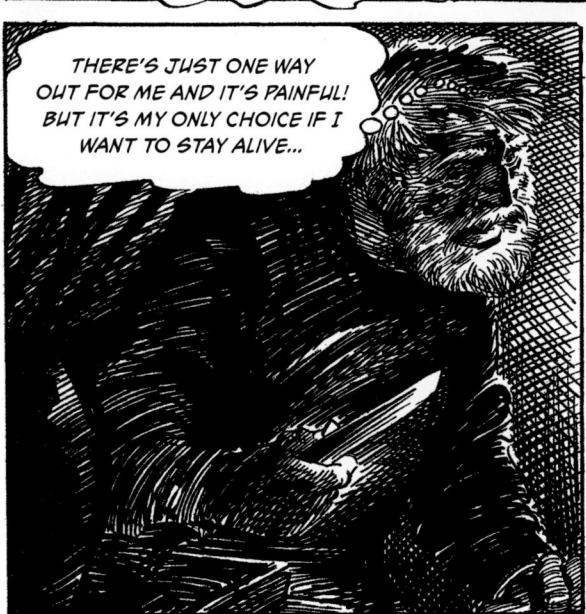
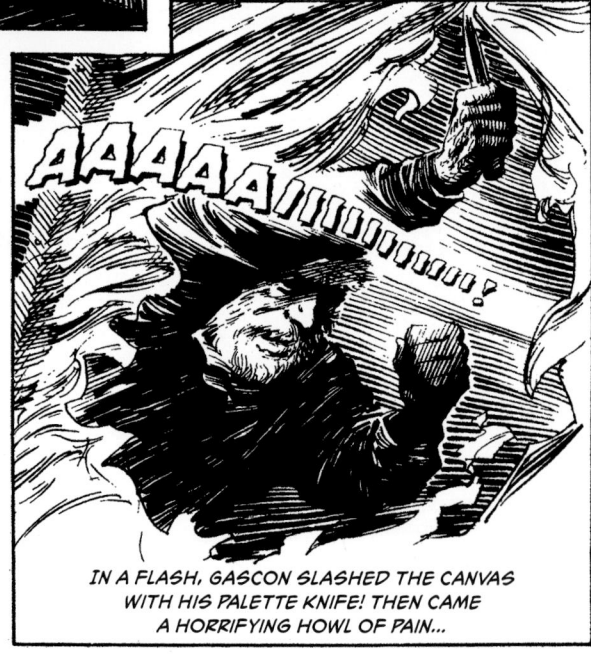
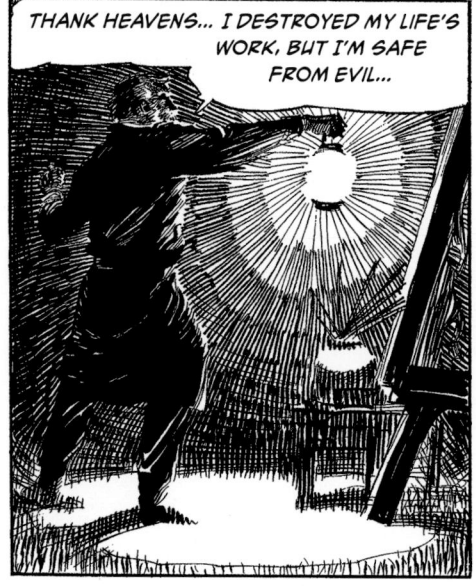
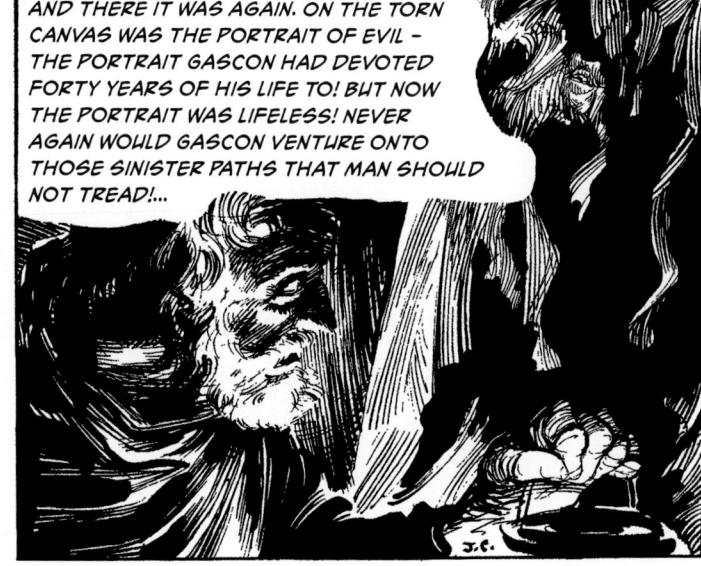

THE PORTRAIT OF EVIL 1973

AS AN ARTIST, Cortez was always responsive to changing tastes among audiences, adapting his style to contemporary aesthetic preferences. This receptivity led him to revise *The Portrait of Evil* in 1973, modernising the story and updating the language to appeal to a 1970s readership. This second version of the comic strip was extended to eight pages, while the graphic artwork of the original was replaced entirely by new illustrations. The plot was also intensified, and the narrative made more cinematographic.

At this point in his career, Cortez was working as the creative director at McCann Erickson, a global advertising agency, and consequently, the language of advertising layouts permeated the prose of the revised edition of *The Portrait of Evil*; recent artistic developments also made their mark on its visual aesthetic, with Cortez's line becoming looser, more stylised, and dynamic.

As an avid connoisseur of art history and artistic movements, Cortez admired the Art Nouveau styling of the Czech artist Alphonse Mucha and the engravings of the French illustrator Gustave Doré. In a stroke of genius, he combined these two artists' respective styles to create a thoroughly original visual aesthetic for his revised version of *The Portrait of Evil*. The painter character, Jules Gascon, was rendered in the Classical style of Doré, while the figure of the demon was depicted using lines reminiscent of Mucha's work. Meanwhile, in stark contrast to the sinuous Art Nouveau style used to portray the abstract and ethereal world of the dead, the world of the living was represented in the Baroque style. This inspired idea to employ two contrasting drawing styles added an additional dimension of artistic refinement to the work. Cortez used the clash of styles to create a kind of sinister tension within the story, and to devastating effect. In *The Portrait of Evil,* Cortez demonstrated the true extent of his artistic virtuosity and gift for creating timeless comic strips.

COUNTLESS PAINTERS HAVE BECOME CONSUMED BY AMBITION, BUT NONE SO MUCH AS GASCON, WHO DEDICATED HIS ENTIRE EXISTENCE TO THE SEARCH FOR SOMETHING HORRIFYING! LET'S BEAR WITNESS TO HIS STRANGE STORY...

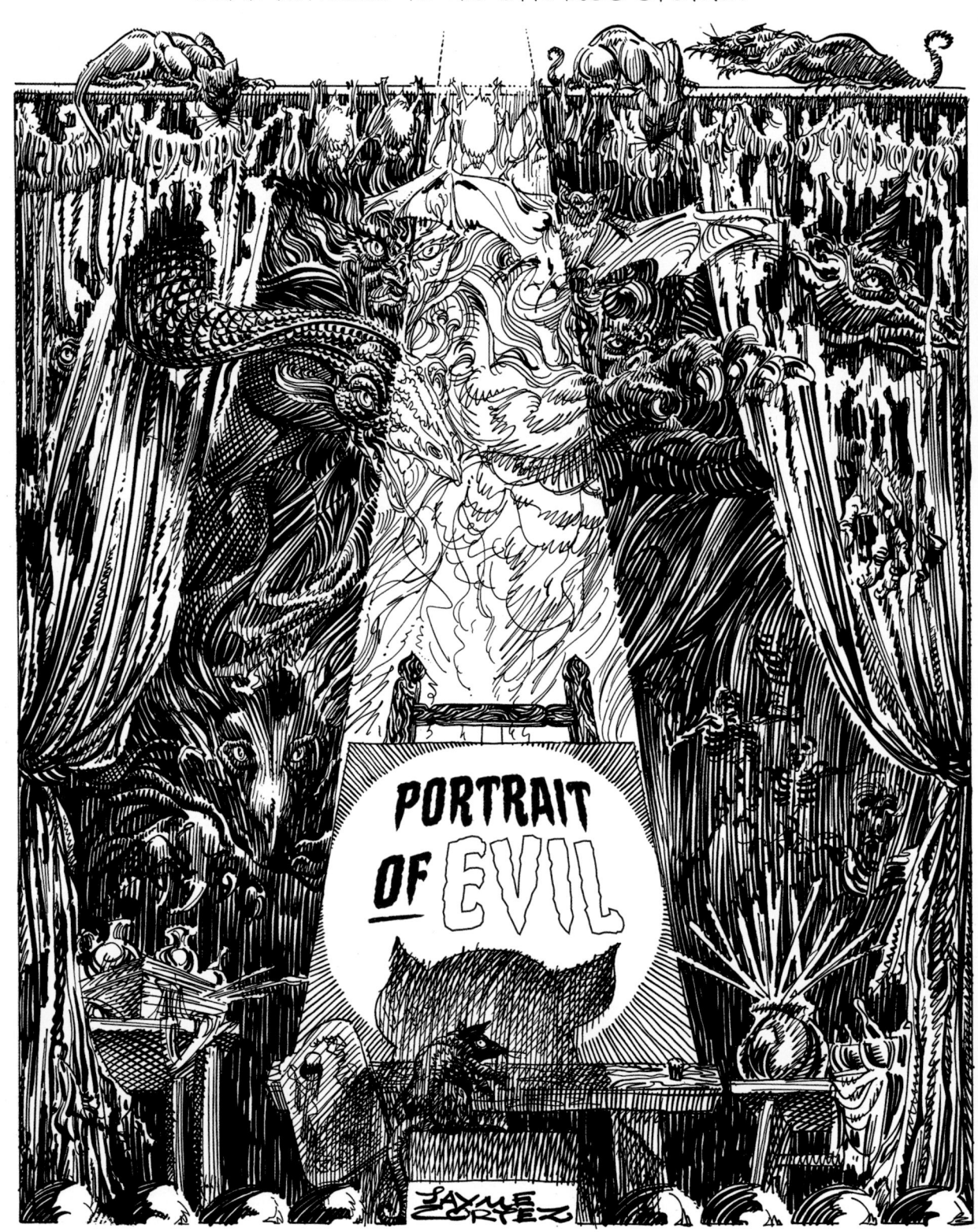

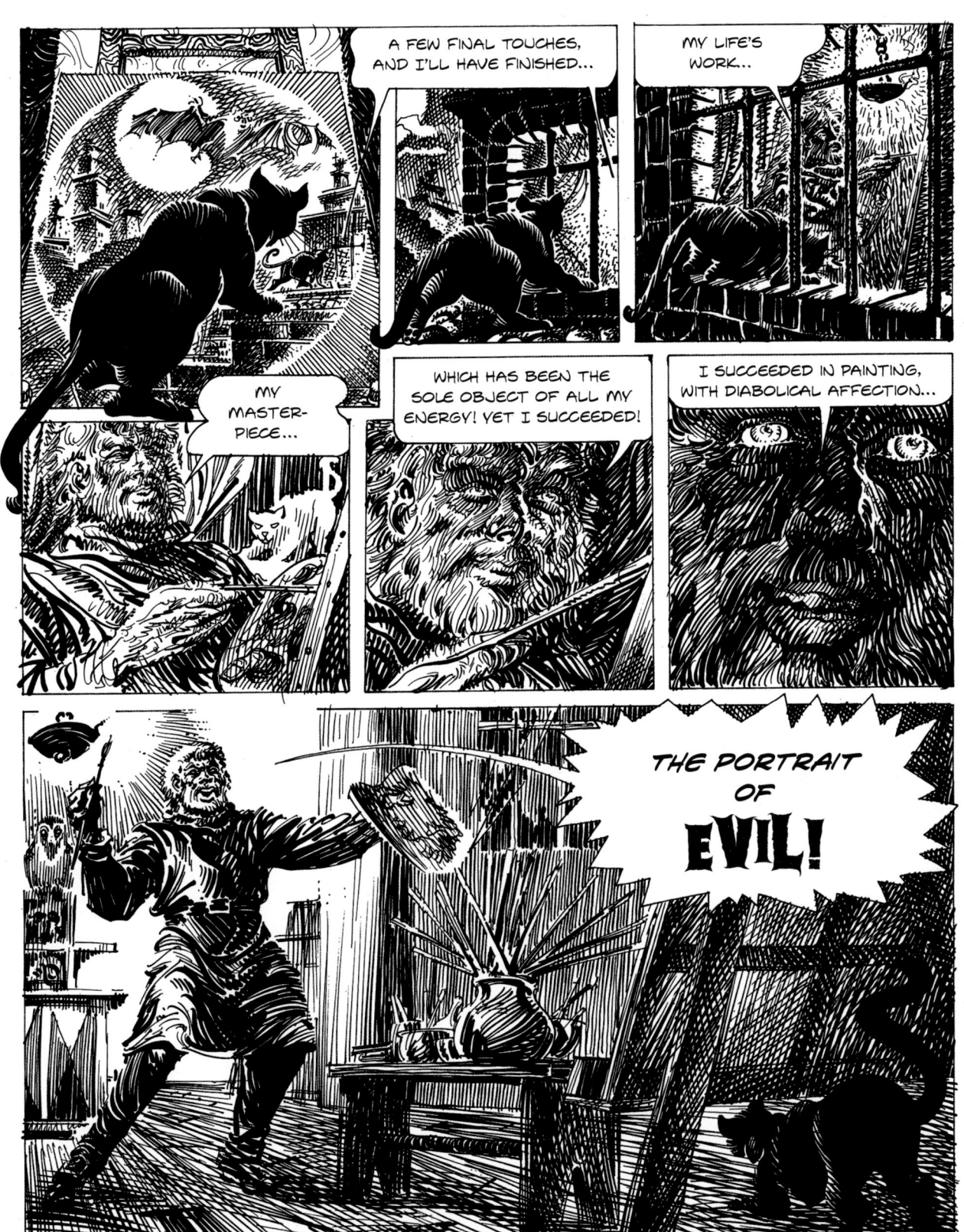

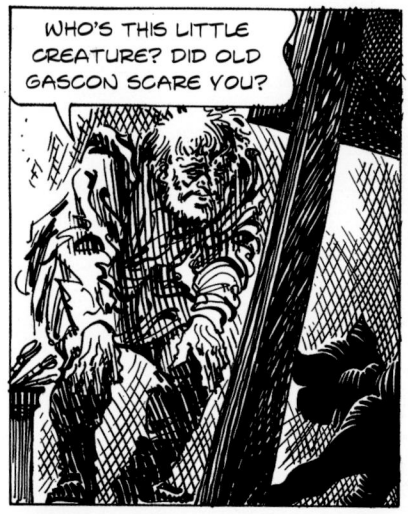
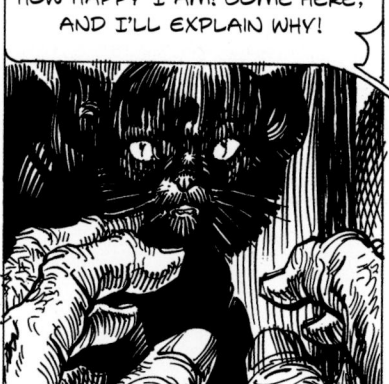
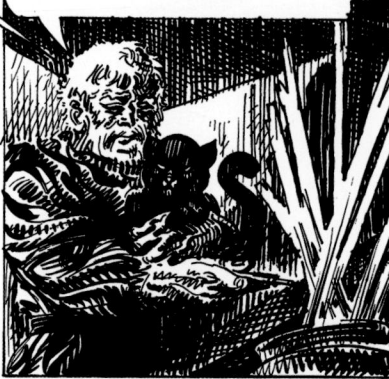
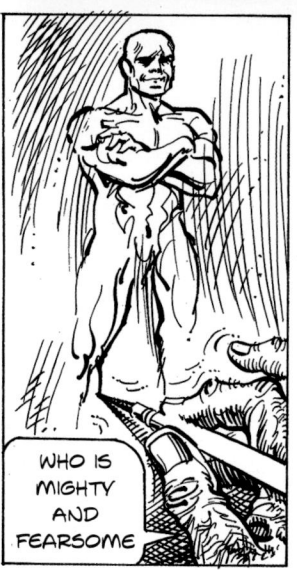
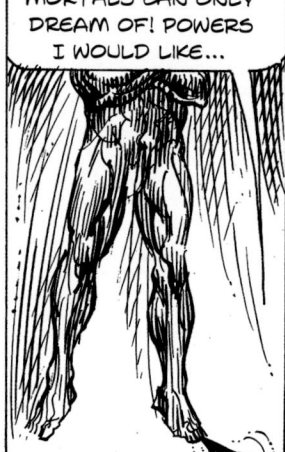
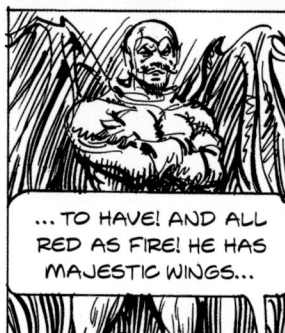

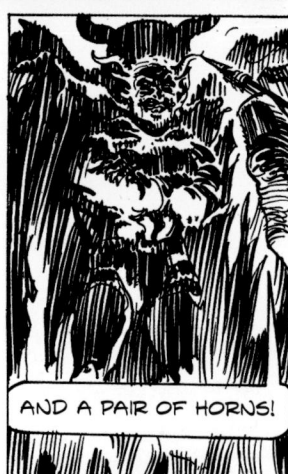
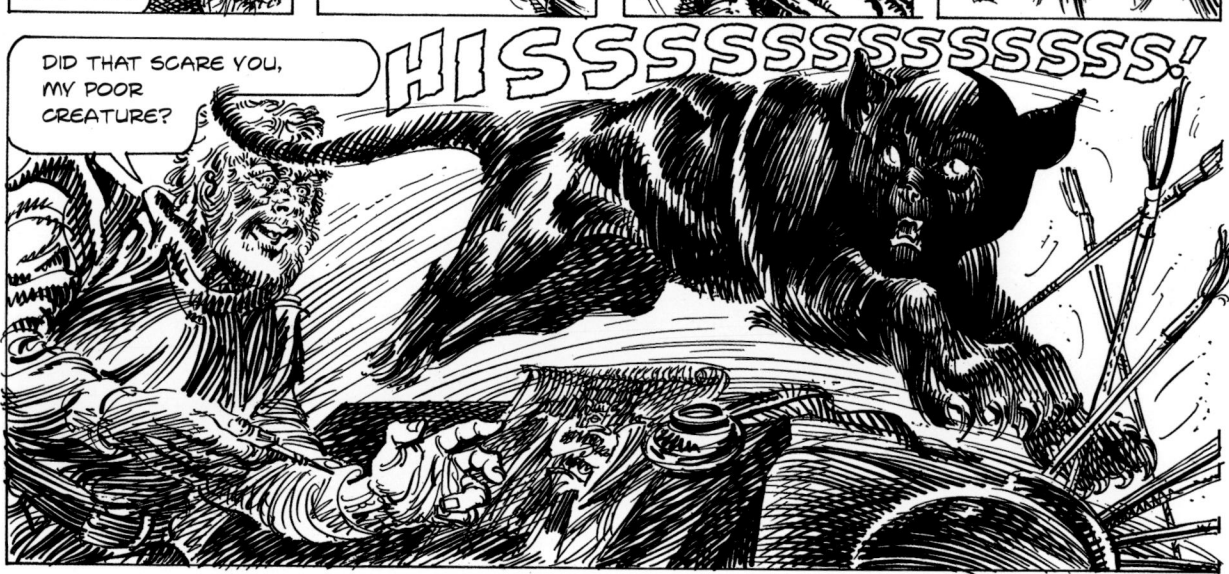

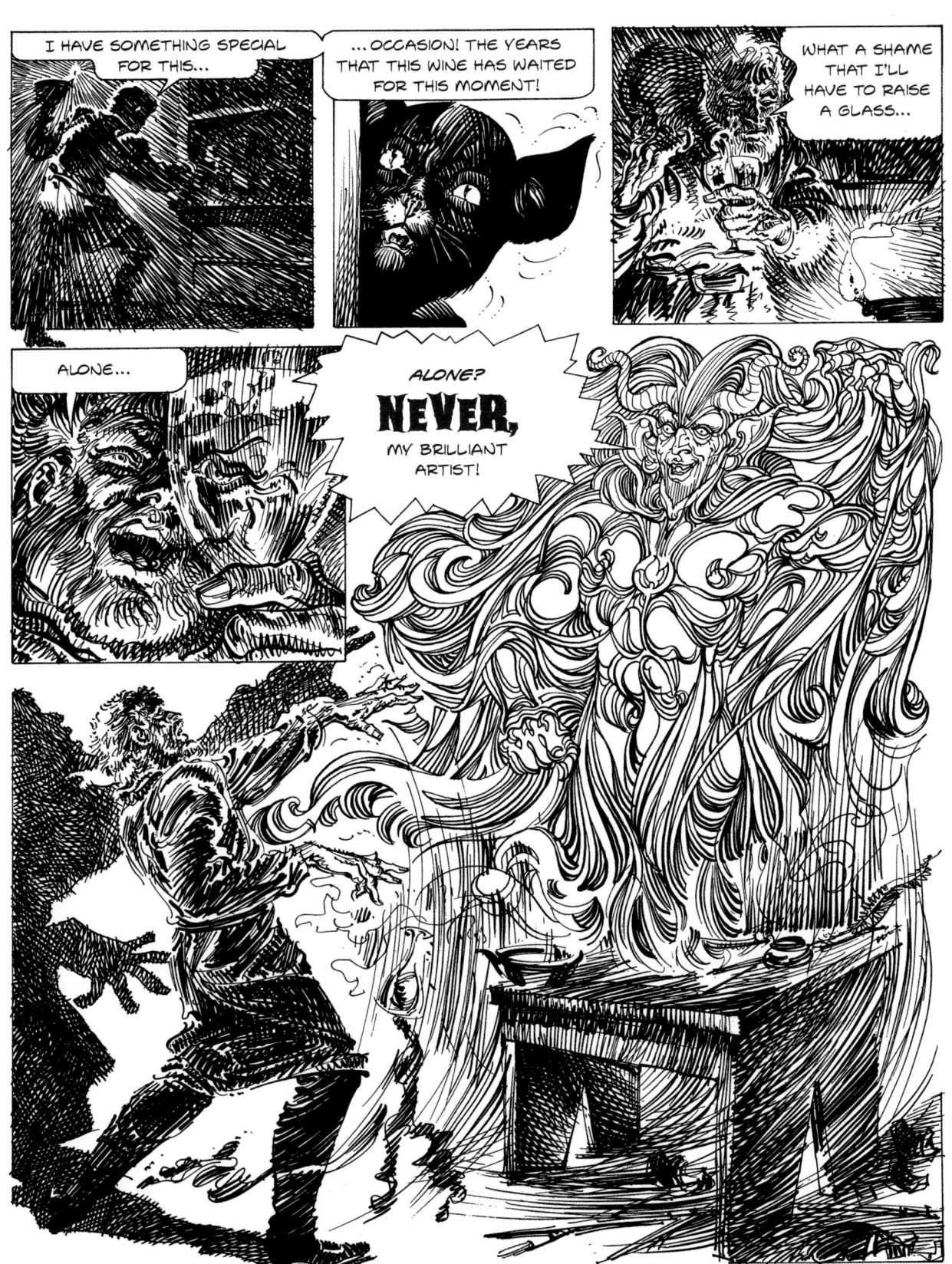

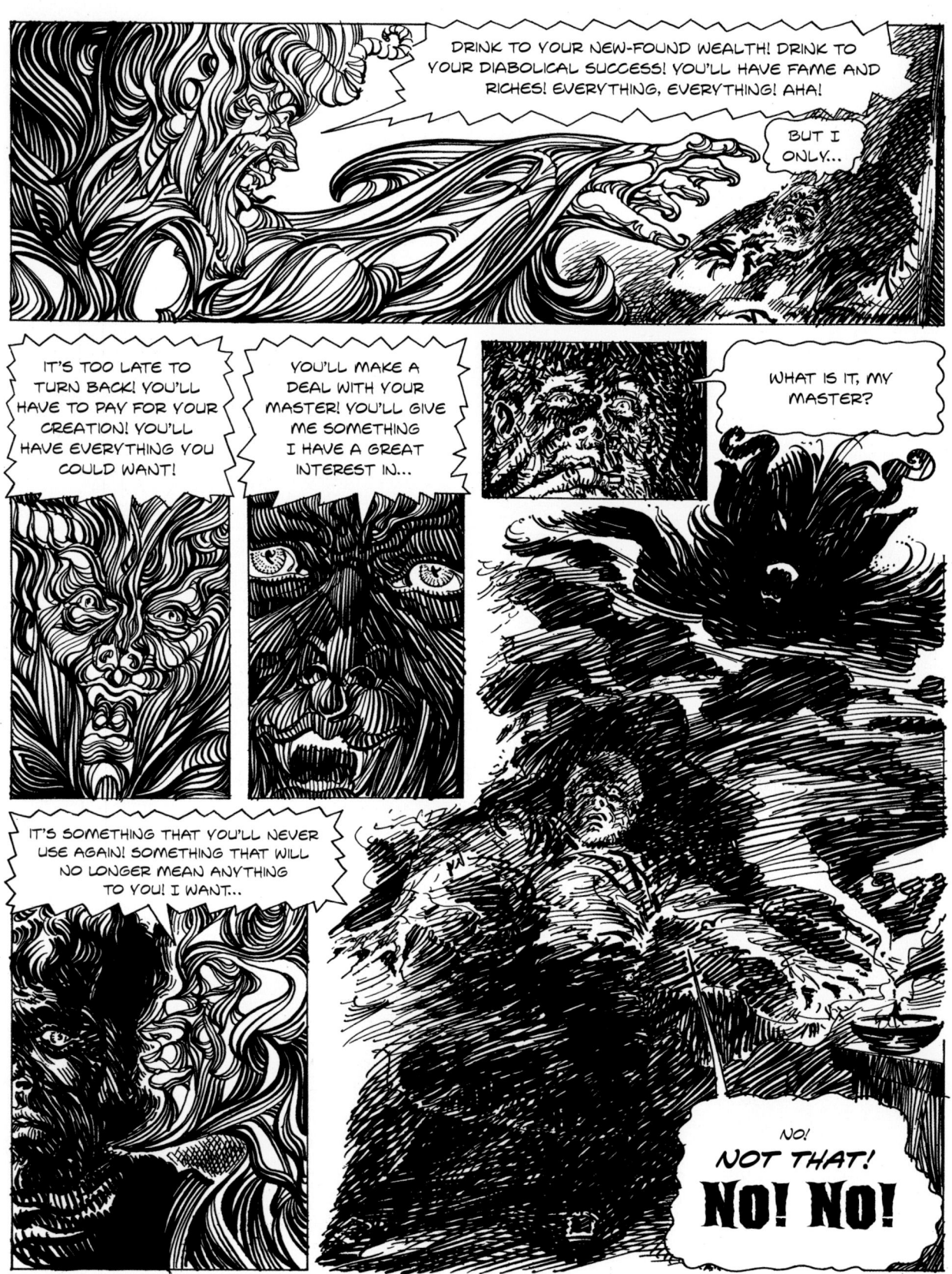

AND SO IT WAS THAT GASCON DESTROYED HIS MASTERPIECE, THE WORK HE CONSIDERED TO BE HIS FINEST PAINTING. NEVERTHELESS, IN DOING SO, GASCON MANAGED TO SAVE THE MOST IMPORTANT THING OF ALL...

...HIS SOUL

THE END

Você já leu as aterradoras aventuras do DRÁCULA?

O terrível **VAMPIRO da NOITE** volta à cena, semeando o terror e a tragédia!

NA MAIS EMPOLGANTE REVISTA DO GÊNERO:

SELEÇÕES DE TERROR

Contendo também uma grande seleção das MELHORES histórias do VERDADEIRO e emocionante gênero de TERROR! Histórias de arrepiar os cabelos!

mensalmente em seu jornaleiro!

SELEÇÕES DE TERROR

1959 – 1967, 62 ISSUES

SELEÇÕES DE TERROR (Terror Selection) was released in 1959 by the newly formed publishing house Continental. Cortez was a partner in the company, along with Miguel Penteado, and to make it look as if they had more than one cover artist on their roster, Cortez would sign some covers M. Penteado. From issue 14, the comic was published under the banner Outubro (Continental's new name). Unfortunately, the publisher's management of the cover dates of all its titles was inconsistent and inaccurate, and so in this book, only the year of publication is given for the Cortez covers shown.

Left: *Seleções de Terror* no. 1, 1959, Continental.

Opposite: Editorial advertisement for *Seleções de Terror*, circa 1965.

Above left: *Seleções de Terror* no. 2, 1959, Continental.
Above right: *Seleções de Terror* no. 3, 1959, Continental.
Left: Jayme Cortez and his wife Edna model for the cover of *Seleções de Terror* no. 2.

Above left: *Seleções de Terror* no. 4, 1959, Continental.
Above right: *Seleções de Terror* no. 5, 1959, Continental.
Left: *Seleções de Terror* no. 6, 1959, Continental.

Above left: *Seleções de Terror* no. 7, 1959, Continental.
Above right: *Seleções de Terror* no. 8, 1960, Continental.
Left: *Seleções de Terror* no. 9, 1960, Continental.

Above left: *Seleções de Terror* no. 10, 1960, Continental.
Above right: *Seleções de Terror* no. 11, 1960, Continental.
Left: *Seleções de Terror* no. 12, 1960, Continental.

Above left: *Seleções de Terror* no. 13, 1960, Continental.
Above right: *Seleções de Terror* no. 14, 1960, Outubro.
Left: *Seleções de Terror* no. 15, 1960, Outubro.

Opposite: *Seleções de Terror* no. 16, 1960, Outubro.

Above left: *Seleções de Terror* no. 17, 1960, Outubro.
Above right: *Seleções de Terror* no. 18, 1960, Outubro.
Left: *Seleções de Terror* no. 19, 1960, Outubro.

Opposite: Original artwork for *Seleções de Terror* no. 18. Watercolour on Fabriano paper; 40 x 28.7 cm.

O IMPÉRIO DO DRÁCULA

Left: *Seleções de Terror* no. 20, 1961, Outubro.
Below: Jayme Cortez poses with a model for the cover of *Seleções de Terror* no. 20.

Opposite: Original artwork for *Seleções de Terror* no. 20. Watercolour on Fabriano paper; 40 x 28 cm.

NAS GARRAS DO DRÁCULA!

M. PENTEADO

O ESCONDERIJO DO
DRÁCULA

M. PENTEADO

Above left: *Seleções de Terror* no. 21, 1961, Outubro.
Above right: *Seleções de Terror* no. 22, 1961, Outubro.
Left: *Seleções de Terror* no. 23, 1961, Outubro.

Opposite: Original artwork for *Seleções de Terror* no. 21. Watercolour on Fabriano paper; 40 x 26.7 cm.

Above left: *Seleções de Terror* no. 24, 1961, Outubro.
Above right: *Seleções de Terror* no. 25, 1961, Outubro.
Left: *Seleções de Terror* no. 26, 1961, Outubro.

Opposite, clockwise from top left: *Seleções de Terror* no. 27, 1961, Outubro; *Seleções de Terror* no. 28, 1961, Outubro; *Seleções de Terror* no. 30, 1961, Outubro; *Seleções de Terror* no. 29, 1961, Outubro.

SELEÇÕES DE TERROR | 55

Above left: *Seleções de Terror* no. 31, 1961, Outubro.
Above right: *Seleções de Terror* no. 32, 1962, Outubro.
Left: *Seleções de Terror* no. 37, 1962, Outubro.

Opposite: Original artwork for *Seleções de Terror* no. 37. Watercolour on Fabriano paper; 40 x 28 cm.

Above left: *Seleções de Terror* no. 39, 1962, Outubro.
Above right: *Almanaque Seleções de Terror*, undated, Outubro.
Right: *Seleções de Terror Almanaque do Drácula*, 1962, Outubro.

Opposite: Original artwork for *Seleções de Terror Almanaque do Drácula*. Watercolour on Fabriano paper; 40 x 28 cm.

ALMANAQUE DO DRÁCULA

O vampiro da noite em histórias inéditas e completas, além de outros contos do verdadeiro gênero de terror!

Above: *Seleções de Terror* extra edition, undated, Outubro.

HISTÓRIAS MACABRAS

1959 – 1966, 54 ISSUES

THE FIRST ISSUE of *Histórias Macabras* (Macabre Stories) was published by Continental in 1959 (from mid-1960, the magazine was issued under the company's newly adopted name, Outubro). Cortez's collaboration with Continental/Outubro lasted from 1959 to 1964, during which time he painted 28 covers for *Histórias Macabras*, with number 41 being the last. After he left the company, other artists took over the production of the comics' illustrations; later, Outubro would occasionally publish a title with a Cortez cover, although these were reprints.

Left: *Histórias Macabras* no. 1, 1959, Continental.

Above left: *Histórias Macabras* no. 2, 1959, Continental.
Above right: *Histórias Macabras* no. 3, 1959, Continental.
Left: *Histórias Macabras* no. 4, 1959, Continental.

Opposite: Original artwork for *Histórias Macabras* no. 4. Watercolour on Fabriano paper; 40 x 27.8 cm.

62 HISTÓRIAS MACABRAS

O SINISTRO CASTELO DE LINDSAY!

Lobisomens atacam em noites de lua cheia... Os mortos voltam a caminhar em visões de pesadelo... Sedentos de sangue, os vampiros povoam as regiões malditas, e um calafrio percorre a sua espinha quando você lê as impressionantes páginas de...

HISTÓRIAS MACABRAS

mensalmente em todos os jornaleiros!

Above left: *Histórias Macabras* no. 5, 1959, Continental.
Above right: *Histórias Macabras* no. 6, 1960, Continental.
Left: *Histórias Macabras* no. 7, 1960, Continental.

Above left: *Histórias Macabras* no. 8, 1960, Continental.
Above right: *Histórias Macabras* no. 9, 1960, Continental.
Left: *Histórias Macabras* no. 10, 1960, Continental.

Opposite: *Histórias Macabras* no. 11, 1960, Continental.

Above left: *Histórias Macabras* no. 12, 1960, Outubro.
Above right: *Histórias Macabras* no. 13, 1960, Outubro.
Left: *Histórias Macabras* no. 14, 1960, Outubro.

Opposite, clockwise from top left: *Histórias Macabras* no. 15, 1960, Outubro; *Histórias Macabras* no. 16, 1960, Outubro; *Histórias Macabras* no. 18, 1961, Outubro; *Histórias Macabras* no. 17, 1960, Outubro.

OS FANTASMAS DO RINCÃO MALDITA!

Above: *Histórias Macabras* no. 19, 1961, Outubro.
Left: *Histórias Macabras* no. 20, 1961, Outubro.

Opposite: Original artwork for *Histórias Macabras* no. 19. Watercolour on Fabriano paper; 40 x 27.6 cm.

Above: *Histórias Macabras* no. 21, 1961, Outubro.
Left: *Histórias Macabras* no. 22, 1961, Outubro.

Opposite: Original artwork for *Histórias Macabras* no. 21. Watercolour on Fabriano paper; 40 x 28.5 cm.

Above left: *Histórias Macabras* no. 23, 1961, Outubro.
Above right: *Histórias Macabras* no. 24, 1961, Outubro.
Left: *Histórias Macabras* no. 25, 1961, Outubro.

Opposite: Original artwork for *Histórias Macabras* no. 25. Watercolour on Fabriano paper; 40 x 28 cm.

Opposite: Original artwork for *Histórias Macabras* no. 40. Watercolour on Fabriano paper; 50 x 36 cm.

Above left: *Histórias Macabras* no. 40, 1963, Outubro.
Above right: *Histórias Macabras* no. 41, 1963, Outubro.
Right: Original artwork for *Histórias Macabras* no. 41. Watercolour on Fabriano paper; 37 x 26 cm.

Above: *Almanaque de Histórias Macabras* no. 1, 1963, Outubro.

CLÁSSICOS DE TERROR

1960 – 1962, 26 ISSUES

CAPITALISING ON the success of their previously released horror comics, Continental launched *Clássicos de Terror* (Terror Classics) in 1960. Cortez painted the covers for issues 1–17, signing some M. Penteado; from issue 11, the publisher's name changed to Outubro. By issue 18, Cortez had become heavily involved with other Outubro titles, so other artists, including Nico Rosso and Lyrio Aragão, produced the covers for *Clássicos de Terror*. Interestingly, however, issues 24 and 26 feature a cover by Cortez: these were probably previously unpublished artworks found in Outubro's archives.

Left: *Clássicos de Terror* no. 1, 1960, Continental.

Above left: *Clássicos de Terror* no. 2, 1960, Continental.
Above right: *Clássicos de Terror* no. 3, 1960, Continental.
Left: *Clássicos de Terror* no. 4, 1960, Continental.

Opposite: *Clássicos de Terror* no. 5, 1960, Continental.

80 CLÁSSICOS DE TERROR

Above left: *Clássicos de Terror* no. 6, 1960, Continental.
Above right: *Clássicos de Terror* no. 7, 1960, Continental.
Left: *Clássicos de Terror* no. 8, 1960, Continental.

Opposite: Original artwork for *Clássicos de Terror* no. 8. Watercolour on Fabriano paper; 40 x 27.4 cm.

A OBRA-PRIMA DE TERROR DE OSCAR WILDE

O RETRATO DE DORIAN GRAY

Opposite: *Clássicos de Terror* no. 9, 1960, Continental.

Above left: *Clássicos de Terror* no. 10, 1960, Continental.
Above right: *Clássicos de Terror* no. 12, 1960, Outubro.
Left: *Clássicos de Terror* no. 13, 1960, Outubro.

CLÁSSICOS DE TERROR 85

Above: *Clássicos de Terror* no. 14, 1961, Outubro.
Left: *Clássicos de Terror* no. 15, 1961, Outubro.

Opposite: Original artwork for *Clássicos de Terror* no. 15. Watercolour on Fabriano paper; 40 x 28 cm.

86 CLÁSSICOS DE TERROR

Above: *Clássicos de Terror* no. 16, 1961, Outubro.

Above: *Clássicos de Terror* no. 17, 1962, Outubro.

Above left: *Clássicos de Terror* no. 24, 1962, Outubro.
Above right: *Clássicos de Terror* no. 26, 1962, Outubro.
Left: *Almanaque Clássicos de Terror* no. 6, 1966, Taika. The publisher Taika bought Outubro and took over some of its titles; the cover of this annual features artwork by Cortez that had not been previously published by Outubro.

HISTÓRIAS SINISTRAS

1960 – 1961, 21 ISSUES

HISTÓRIAS SINISTRAS (Sinister Stories) was another successful horror magazine from Outubro, for which Jayme Cortez produced the early covers. The painting technique that the artist used to create the *Histórias Sinistras* covers is particularly expressive, with aggressive brushstrokes and a heavy use of contrasting colours that conjures up disturbing, highly atmospheric horror scenes filled with a suffocating sense of dread.

Left: *Histórias Sinistras* no. 1, 1960, Outubro.

92 HISTÓRIAS SINISTRAS

Opposite, clockwise from top left: *Histórias Sinistras* no. 2, 1960, Outubro; *Histórias Sinistras* no. 3, 1960, Outubro; *Histórias Sinistras* no. 5, 1960, Outubro; *Histórias Sinistras* no. 4, 1960, Outubro.

Above: Original artwork for *Histórias Sinistras* no. 5. Watercolour on Fabriano paper; 40 x 27

Above left: *Histórias Sinistras* no. 6, 1960, Outubro.
Above right: *Histórias Sinistras* no. 7, 1960, Outubro.
Left: *Histórias Sinistras* no. 8, 1960, Outubro.

Above left: *Histórias Sinistras* no. 9, 1961, Outubro.
Above right: *Histórias Sinistras* no. 10, 1961, Outubro.
Left: *Histórias Sinistras* no. 11, 1961, Outubro.

Above: *Histórias Sinistras* no. 12, 1961, Outubro.

HISTÓRIAS DO ALÉM

1960 AND 1965/1966, 4 ISSUES

HISTÓRIAS DO ALÉM (Stories from the Beyond) was a short-lived magazine. Continental released the first three issues in 1960, and during 1965 and 1966, the titles were reprinted under the Outubro banner, along with a fourth issue. The cover designs of the first three issues differed in their treatment from many of the publisher's other titles in that they were drawn with Indian ink and then coloured, giving them the look and feel of much earlier comic books. Jayme Cortez illustrated the cover of issue four in his more painterly style.

Left: *Histórias do Além* no. 1, 1960, Continental.

Above left: *Histórias do Além* no. 2, 1960, Continental.
Above right: *Histórias do Além* no. 3, 1960, Continental.
Right: Colour guide for *Histórias do Além* no. 3.

Opposite: Original line artwork for *Histórias do Além* no. 3. Indian ink on paper; 20.7 x 19 cm.

98 | HISTÓRIAS DO ALÉM

HISTÓRIAS DO ALÉM | 99

Above: *Histórias do Além* no. 4, 1966, Outubro.

SUPER BÔLSO

1963, 3 ISSUES

RUBENS FRANCISCO LUCCHETTI, better known as R.F. Lucchetti, the father of Brazilian pulp fiction, debuted at Outubro in 1963 with these three pocket books. The covers and internal illustrations were produced by Jayme Cortez. Over the years, Lucchetti wrote numerous detective and mystery stories, radio shows, TV and film scripts, comic book scripts, and photo-novels. Lucchetti and Cortez enjoyed a friendship that lasted until the illustrator's death in 1987.

Left: Cover of *Noite Diabolica* (Diabolical Night), *Super Bôlso* no. 201, 1963, Outubro. See also the black and white illustrations on pages 118–119.

Above: *O Dóbre Sinistro* (The Sinister Double), *Super Bôlso* no. 202, 1963, Outubro.
Left: *O Ouro dos Mortos* (The Gold of the Dead), *Super Bôlso* no. 502, 1963, Outubro.

TERROR MAGAZINE

1963 - 1964, 3 ISSUES

TERROR MAGAZINE was another short-lived title from the publisher Outubro. The magazine was unusual in that it contained a mixture of short stories and comic strips; the title of the main short story was featured on the cover. All three covers, which Jayme Cortez painted, are dominated by a large head whose fearsome appearance is accentuated by white highlights.

Left: *Terror Magazine* no. 1, 1963, Outubro.

Above: *Terror Magazine* no. 2, 1963, Outubro.
Left: *Terror Magazine* no. 3, 1964, Outubro.

JOTAESSE

THE COMICS PUBLISHER Jotaesse (originally Regiarte) was known for its horror titles. The company's owner, José Sidekerskis, was a former partner at Outubro and one of the founders of Ática publishing house. Knowing that *Dracula* was a bestseller for the rival publisher Taika, Sidekerskis launched comics such as *O Vampiro* (The Vampire) and *Mirza, a Mulher Vampiro* (Mirza, the Vampire Woman). Jayme Cortez painted a handful of the company's covers; Jotaesse's regular cover artists were Eugênio Colonnese and Rodolfo Zalla. The short-lived publishing house folded in the 1970s.

Left: *O Vampiro* no. 5 November 1966, Jotaesse.

Top row: *O Vampiro* no. 7, January 1967, Jotaesse; *O Vampiro* no. 8, Feburary 1967, Jotaesse; *O Vampiro* no. 9, March 1967, Jotaesse. **Middle row:** *O Vampiro* no. 10, April 1967, Jotaesse; *O Vampiro* no. 11, May 1967, Jotaesse; *O Vampiro* no. 12, June 1967, Jotaesse. **Bottom row:** *Mirza, a Mulher Vampiro* (Mirza, the Vampire Woman) no. 1, April 1973, Jotaesse; *Lendas Sinistras* (Sinister Legends) no. 2, November 1970, Jotaesse.

Opposite: *Almanaque de O Vampiro* no. 1, March 1968, Jotaesse.

ALMANAQUE DE O VAMPIRO

Cr$ 700,

"PARA ADULTOS

EDGAR ALLAN POE

DURING HIS CAREER, Jayme Cortez built up a broad repertoire of illustration techniques. He regularly varied his style from pen and ink line drawings to more painterly and psychedelic artworks, especially in his later years. The four images featured in this section are based on well-known tales of horror by the American writer Edgar Allan Poe (1809–1849). For these images, Cortez first made a drawing in pencil, which he then inked with a technical pen on Fabriano paper and coloured with Ecoline liquid watercolour ink. With the exception of *The Masque of the Red Death*, which was used for the cover of *Saga de Terror* (Saga of Terror), published by Martins Fontes in 1987, they remained unutilized.

Left and below: *The Masque of the Red Death*, Edgar Allan Poe, 1980. Cover of *Saga de Terror*, Martins Fontes, 1987.

Opposite, clockwise from top left: *The Black Cat*, Edgar Allan Poe, 1980; *The Raven*, Edgar Allan Poe, 1980; *The Pit and the Pendulum*, Edgar Allan Poe, 1980; *The Pit and the Pendulum* pencil study, Edgar Allan Poe, 1980.

EDGAR ALLAN POE | 109

CREATING A POSTER
FINIS HOMINIS (THE END OF MAN), 1971

ON THE 1970s, Brazil was home to a flourishing film industry known as Cinema da Boca do Lixo (Garbage Mouth Cinema), named after a downtown neighbourhood of São Paulo that was both famous and notorious for its nightclubs and prostitutes, and nicknamed Boca do Lixo (Garbage Mouth). Personally acquainted with many of the artists, directors, and producers of these films, Jayme Cortez was often approached to illustrate posters for them. In this section, Cortez describes his process for creating the poster for *Finis Hominis* (The End of Man) – an exploitation film directed by José Mojica Marins about a mysterious man from an insane asylum who gains prominence as a messiah figure.

A movie poster should try to recreate the atmosphere and mood of the film it promotes. Typically, the producer will supply the artist with photos of the most evocative scenes and a synopsis of the story on which the artist can base their ideas. Ideally, the artist should watch a preview of the film to help them produce a design capable of arousing the public's interest. For the majority of international movie posters, especially American films, specific photos will need to be taken, as the scene photos from the film are often unsuitable.

The artist should first create a rough layout that includes lighting effects and text placement; this will be used as a guide by the film's production team to produce reference photos during the film's final production phase, while all the film's production elements, such as props and costumes, are still available. The photoshoot for the poster should be supervised by the artist, who will direct the composition, including the lighting, to ensure the photos produced align with their vision. Members of the film's production team and the director of photography should provide the necessary technical assistance.

CREATING A POSTER | 111

This facial close-up (above) is crucial and requires an entirely different lighting composition than is used for the main image on the poster. The eyes, which will form the background to the main image, are painted using gouache. Below is the photo chosen as the poster's central element. The photo is enlarged to the required size, on top of which a black outine is drawn, in ink, to define the colour fields.

The photograph is erased using chemicals, leaving just the black linework, which is then coloured using watercolour paints. At that time, in the absence of computer-generated graphic techniques, the final step of the process was to cut and paste the larger elements over the painting of the eyes. The title and other textual elements were then added during the photolithography process.

112 | CREATING A POSTER

CREATING A POSTER | 113

Above: Poster for *Ilha dos Mortos* (*Isle of the Dead*), 1945, directed by Mark Robson.

Opposite, clockwise from top left: *Excitação* (*Excitement*), 1976, directed by Jean Garret; *Monstro de um Mundo Perdido* (*Mighty Joe Young*), 1949, directed by Ernest B. Schoedsack; *A Maldição de Sangue de Pantera* (*The Curse of the Cat People*), 1944, directed by Gunther V. Fritsch and Robert Wise; *A Morte Comanda o Cangaço* (*Death Commands the Cangaço*), 1960, directed by Carlos Coimbra.

CREATING A POSTER | 115

BLACK AND WHITE ILLUSTRATIONS

IN ADDITION TO his colour artwork for magazine covers, Jayme Cortez drew numerous interior black and white illustrations with pen and ink. It is in these images, drawn to illustrate stories, articles, and editorial advertisements, that one can clearly recognise Cortez's artistic abilities. Stand-out works include his illustrations for *D.O. Leitura*, the cultural supplement of the *Official Gazette of the State of São Paulo*, and the spot pictures he drew for the stories of R.F. Lucchetti (see page 101). It is worth observing Cortez's change of style across all his output as the decades progressed – his later works are surprisingly different in tone and style than those he created in the 1950s and early 1960s.

Opposite: Poster artwork for Calafrio no. 19 (1983), the Cortez special edition (see page 25).

Below: *O Médico e o Esqueleto*, *D.O. Leitura*, September 1984.

Above and opposite: Illustrations for the pocket book *Noite Diabolica* (Diabolical Night) by R.F. Lucchetti that made up issue 201 of *Super Bôlso*, 1963, Outubro (see page 101).

BLACK AND WHITE ILLUSTRATIONS | 119

Contents page illustration for *Spektro* magazine no. 9, 1979, Vecchi.

Above: Illustration for the short story "O Segredo do Dr. Roger Blackhill" by R.F. Lucchetti, for *O Grande Livro do Terror* (The Great Book of Terror), 1978, Argos.
Below: Illustration made as a poster for the magazine/portfolio *A Arte de Jayme Cortez*, 1986, Editorial Press.

Above and right: Various illustrations of editorial advertising from Outubro.

Following page: Boris Karloff in *O Grande Livro do Terror* (The Great Book of Terror), 1978, Argos.

▲ **BORIS KARLOFF**
(CHARLES EDWARD PRATT – DULWICH, 1887 – MIDHURST, 1969)

ACKNOWLEDGEMENTS

THIS BOOK IS, first and foremost, a tribute to Jayme Cortez, who left us his magnificent works. My deep affection to the Cortez family, who I thank.

I wish to express my indebtedness to Paulo Monteiro for his invaluable help. He is an exceptional artist, a fan of Jayme Cortez, and as the director and organiser of the International Comics Festival of Beja (Portugal) and the director of the International Museum B.D. of Beja, he is one of the people most committed to promoting Portuguese comics.

My gratitude to my friend Paul Gravett, the world's greatest comics promoter and researcher, who was instrumental in making volumes 1 and 2 of *The Horror Comic Art of Jayme Cortez* a reality.

My sincere thanks to Yahya El-Droubie at Korero Press for publishing this book.

And in addition, I thank all those collectors and researchers who helped with images, especially Skye Ott with his gigantic collection of Brazilian comics.

FABIO MORAES

ALSO AVAILABLE FROM KORERO PRESS

Terror: The Horror Comic Art of Jayme Cortez, Volume 1

Sex and Horror Volume 1
The Art of Emanuele Taglietti

Sex and Horror Volume 2
The Art of Alessandro Biffignandi

Mondo Erotica
The Art of Roberto Baldazzini

Sex and Horror Volume 3
The Art of Fernando Carcupino

Sex and Horror Volume 4

Horizontal Collaboration
by Navie and Carol Maurel

Sex and Horror Volume 5
The Art of Roberto Molinio

For news of new releases, events and offers we recommend you sign up for our newsletter and follow us on social media @koreropress. Our books can be found in traditional bricks and mortar bookshops, or purchased directly from our website and elsewhere online.

www.koreropress.com

ALSO AVAILABLE | 127

WWW.KOREROPRESS.COM